EXPRESSIONISM

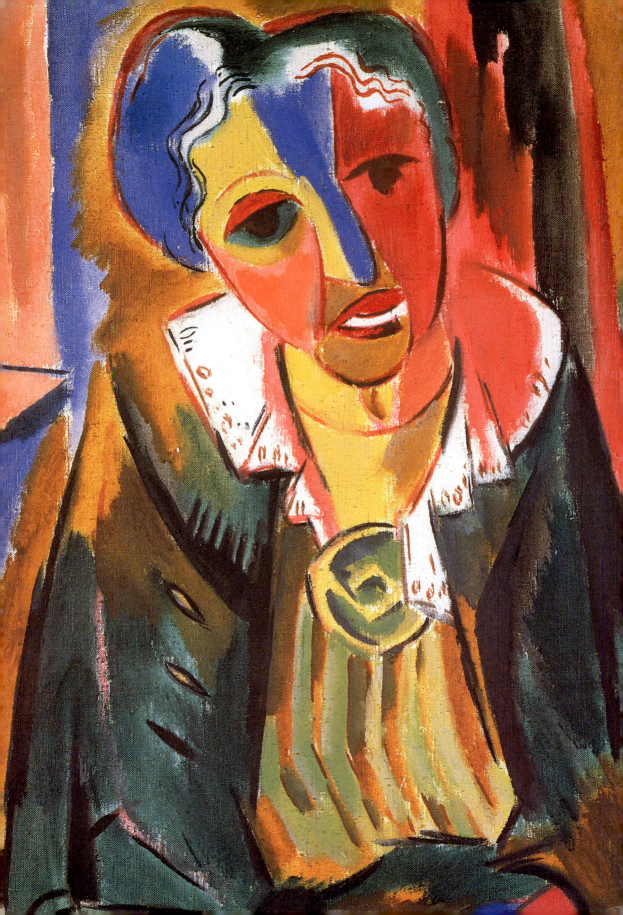

MOVEMENTS IN MODERN ART

EXPRESSIONISM

SHULAMITH BEHR

CAMBRIDGE
UNIVERSITY PRESS

PUBLISHED BY THE PRESS SYNDICATE OF THE
UNIVERSITY OF CAMBRIDGE
The Pitt Building, Trumpington Street, Cambridge
United Kingdom

CAMBRIDGE UNIVERSITY PRESS
The Edinburgh Building, Cambridge CB2 2RU, United Kingdom
http://www.cup.cam.ac.uk
40 West 20th Street, New York, NY 10011-4211, USA
http://www.cup.org
10 Stamford Road, Oakleigh, Melbourne, 3166, Australia
Ruiz de Alarcón 13, 28014 Madrid, Spain

First published by Tate Gallery Publishing Ltd, London 1999

Cover designed by Slatter-Anderson, London
Book designed by Isambard Thomas
Typefaces/Monotype Centaur (9/10.5 pt)
and Adobe Franklin Gothic
System (Apple Macintosh) [IT]

Printed in Hong Kong by South Sea International Press Ltd

A catalogue record for this book is available from the British Library

Library of Congress Cataloguing-in-Publication Data is available.

Measurements are given in centimetres, height before width,
followed by inches in brackets

Cover:
Georg Grosz,
Suicide 1916 (detail of fig.44)

Frontispiece:
Karl Schmidt-Rottluff,
Portrait of Rosa Schapire 1919 (detail of fig.47)

ISBN 0 521 78847 1

Contents

EXPRESSIONISM: ITS ORIGINS, MEANINGS AND HISTORIOGRAPHY

Of all the 'isms' in the early twentieth century, Expressionism is one of the most elusive and difficult to define. The term has entered the language, and nowadays any artist may be deemed 'expressionist' if they exaggeratedly distort form and apply paint in a subjective, intuitive and spontaneous manner. Indeed, when the American picture magazine *Life* first popularised 'Expressionism' in May 1958, it did so by assuming that emotional excess was the norm of Expressionist art, accompanying illustrations with captions such as 'Violent Images of Emotion . . . Horror and Anxiety' or 'Power of Love'. Yet this kernel concept of the 'expressive' – the primacy of the creative process at the expense of verisimilitude – cannot be reduced solely to a matter of an artist's temperament. As we shall see, such a notion had a rich and complex heritage in turn-of-the-century German culture, aesthetic practice and theory.

As in the case of Fauvism and Cubism, the label wasn't invented by the artists themselves but flourished in promotional literature and critical reviews of current exhibitions. However, Expressionism did not constitute a cohesive movement or style; individual artists and groups were widely dispersed and differed in their background and training. The professional status of artists underwent immense transformation during the 1890s, as they rejected the traditional channels of training in state academies in favour of the studios of progressive and established mentors. Women artists, too, barred from academic training, sought tuition in the private sphere.

It is understandable why, even in tracing the origins of the term, the definition has inspired considerable dissension among scholars. Interestingly, the term 'Expressionisten' was initially applied to a selection of French, and not German artists, in the foreword to the catalogue of the twenty-second spring exhibition of the Berlin Secession held in April 1911. Apart from Picasso, most of these artists were associated with the circle of Matisse – Braque, Derain, Friesz, Marquet, van Dongen, among others. Given the largely Impressionist leanings of the Secession, the collective term 'Expressionisten' was a convenient way of signifying the 'newest directions' in French art.

In his 1966 article 'On the origin of the word "Expressionism"', the art historian Donald E. Gordon contended that in Germany the term 'expression' was an imported phenomenon, having been widely used in the studio of Matisse in Paris and published in the artist's well-known theoretical treatise of 1908, *Notes d'un peintre* (Notes of a Painter). This use of the term was publicised by young German artists in the circle of Matisse, the sculptor Greta Moll translating his treatise in the journal *Kunst und Künstler* (Art and Artists) in 1909. In *Notes of a Painter*, Matisse claimed that 'expression' did not constitute the mirroring of passion 'upon a human face or betrayed by a violent gesture' but formal considerations: 'The whole arrangement of my picture is expressive . . . Composition is the art of arranging in a decorative manner the various elements at the painter's disposal for the expression of his feelings.'

Other researchers in the field, most recently Marit Werenskiold and Ron Manheim, have questioned Gordon's findings. They have shown that the opposition set up between the recording of external appearances by the Impressionists, and the Expressionist response to the imperatives of an inner world, was common outside France at the time. Indeed, even Roger Fry considered Expressionism a feasible title for his first Post-Impressionist exhibition, held at the Grafton Galleries in London in 1910, in order to distinguish the works of van Gogh, Gauguin and Cézanne from the Impressionists. One can assume that the author of the Berlin Secession catalogue foreword, possibly the newly elected president Lovis Corinth, had similar ideas.

Furthermore, Ron Manheim has queried whether it was actually necessary to import the French term 'expression' into German critical writing. He has revealed that the German equivalent 'Ausdruck' was employed to differentiate recent tendencies from Impressionist culture ('Eindruckskultur'). In his 1907 editorial report for the magazine *Der Kunstwart* (The Curator), Ferdinand Avenarius defined 'Ausdruckskultur' (Expressionist culture) as that which constitutes a 'harmony of essence and appearance' and which cultivates the 'national spiritual goodness and general humanity lodged in the German nation'. There is evidence to show that Expressionism was considered a distinctly German rather than an imported trend and the political inflections of the First World War consolidated this viewpoint.

Before 1914, in an attempt to reform German culture in accordance with a vitalist, modernising aesthetic, Expressionism was sponsored in the public domain. At the Sonderbund Exhibition held at the Cologne Kunsthalle in 1912, the director of the exhibition, Richart Reiche, used the umbrella label

'Expressionismus' in the foreword to the catalogue, and applied it to a range of new art drawn from France, Germany, Austro-Hungary, Switzerland, Holland, Norway and Russia. Yet, at the same time, members of the German group Brücke (Bridge) were commissioned to decorate a chapel installed specifically for the occasion. Moreover, the importance attributed to the works of van Gogh, and a retrospective of the Norwegian artist Edvard Munch, indicated the attempt to establish a specifically northern, as opposed to a French, lineage for the Expressionist movement. In these efforts, the Sonderbund was encouraged by the banking millionaire, Karl Ernst Osthaus, who, as founder and director of the Folkwang Museum in Hagen, was responsible for an unusual degree of public patronage with private funds.

In 1914, the term accrued its specifically German connotations. In that year, the critic and newspaper feuilletonist Paul Fechter, in his book *Der Expressionismus* (Expressionism) (fig.1), applied the term to the works of Brücke artists, to Der Blaue Reiter, and to individuals such as Oskar Kokoschka. Fechter dismissed the decorative, cosmopolitan associations of the word, investing it with connotations of the anti-intellectual, the emotional and the spiritual – the 'metaphysical necessity of the German people'. Fechter's text drew heavily on the art historian Wilhelm Worringer's professorial thesis *Formprobleme der Gotik* (Form in Gothic), published in 1911, which constructed a genealogy for German artistic identity based on the anti-classical features of the German Gothic past. The book's cover illustration of a saint by Max Pechstein (a member of the Brücke group between 1906 and 1912) suitably conveys an attempt to associate Expressionism with the distorted stylisations of this tradition.

While pre-war definitions of Expressionism were somewhat vague, they gained coherence in various publications during the war. The Austrian critic and playwright Hermann Bahr published the book *Expressionismus* in 1916, which was widely read, reaching three editions by 1920. He reaffirmed Expressionism's opposition to Impressionism, justifying its shock impact as a necessary antidote to bourgeois order and complacency. Consistent with methodologies in art historical enquiry of the period (he cites Worringer and Alois Riegl), he viewed contemporary art production as reflective of the despair of the age: 'Misery cries out, man cries out for his soul, the entire time is a single scream of distress.' With the Revolution of November 1918 in Germany and the collapse of the Second Reich, such intellectuals saw the opportunity for the initiation of a new society, and the link between Expressionism and revolutionary theory became more emphatic.

A second generation of Expressionists emerged which, while widespread in regional centres throughout Germany, was more cohesively defined by its members' anti-war sentiments and engagement in the political fervour of the early Weimar Republic. In his essay 'Expressionismus und Sozialismus'

(Expressionism and Socialism), published in the journal *Neue Blätter für Kunst und Dichtung* (New Newspapers for Art and Poetry) in May 1919, the political editor and art critic Herbert Kühn proclaimed: 'Expressionism is – as is socialism – the same outcry against materialism, against the unspiritual, against machines, against centralisation, for the spirit, for God, for the humanity in man.' At the heart of Expressionist theory lay the paradox that the personal 'strivings' and subjective expression of the artist could nonetheless rekindle utopian notions of spiritual community and identity. As counter-revolutionary tendencies became more predominant in the Weimar Republic, so disillusionment set in with Expressionism's inability to provide a politically effective platform.

It is clear that, since the 1966 publication of Gordon's pivotal article outlined earlier, research in the field of Expressionism has expanded considerably. Yet art history itself has undergone re-evaluation due to an increasing overlap with social and cultural studies. Admittedly, it cannot be proven that *all* German artists before 1914 held a single 'communality of interests', as Gordon put it, but it is possible to detect allegiances of a different sort across the various groupings. To do this however, we need to examine conditions beyond the origins of the term or a possible homogeneity of style. These include the 'range of institutions, artifacts and practices' (Milner 1994) that made up the symbolic universe of Expressionist avant-garde culture: the artists' promotion of an authentic and innovatory aesthetic, their social and political status, their relation to official or professional associations and their search for new patrons and exhibiting outlets.

FRAMING EARLY EXPRESSIONISM: THE STATE, SECESSIONS AND AVANT-GARDISM

When we talk about Expressionism as constituting a major avant-garde movement, we accept the premise that Expressionists were aware of a progressive modern cultural identity. This applied to the twenty-six-year-old Ernst Ludwig Kirchner in Dresden who, in the manifesto of the artists' group Brücke in 1906 (fig.2), called to all youth to embody 'the future' and to free themselves 'from the older, well-established powers'. It also applied to the forty-three-year-old Russian Wassily Kandinsky in Munich. In a letter to the director of the Bavarian State Museums Hugo von Tschudi, Kandinsky declared the formation of the Neue Künstlervereinigung (New Artists Association) in 1909, a group which believed that the work of art embraced the 'bud of the future and caused it to flourish'. His design for the poster advertising the first exhibition of the Association in the same year (fig.3) distils these aims into radically abstract, emblematic landscape and figural motifs.

Explicit in these statements is a utopian belief in the evolutionary power of art and its ability to transform society. Implicitly, however, they alert us to the fact that the avant-garde's claim to an abstract and honest aesthetic lies well beyond the comprehension of contemporary taste. Such ideas owed much to the dominant intellectual influence of Friedrich Nietzsche who propagated a romantic form of liberalism, emphasising the conquest of the self and the

development of the creative powers of the individual. Even artists as marginalised from mainstream developments as twenty-three-year-old Paula Modersohn-Becker in the Worpswede colony, north of Bremen, entered in her diary on 3 March 1899: 'Finished [Thus Spake] Zarathustra. A wonderful work ... Nietzsche with his new values – yes, he is a giant. He holds his reins taut and demands the utmost of his energies. But isn't that true education?'

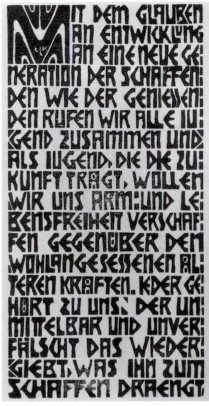

A Nietzschean idea of artistic struggle couched in military imagery became integral to the avant-garde's declaration of independence from older established forces, although against whom or what they were rebelling is left quite unspecific. Histories of modern art have accepted such declarations as implicit evidence and subsumed this rebellion into an overall pattern of events dependent on the conflict between the polarities new versus old, sons versus fathers, modernism and the private individual versus their arch enemies, the academy and the state. These binary oppositions at times serve to conceal the complex factors surrounding avant-gardism. In the period of capitalism and economic expansion in Germany to which we are referring, c.1892 to 1913, the alienation of the artist from the training and supportive mechanisms of the state necessitated the establishment of alternative networks for reaching a public. The formation of communal groups and their interaction with private dealers remind us that, as unacceptable as it may have seemed to its participants, the avant-garde 'was and is a concept ruled by the market place', as the art historian Robert Jensen has put it. Jensen furthermore recognises the 'irreconcilable conflict between the idealistic ambitions of modernist artists and their commercial practices'.

Such developments were presaged by the formation of 'secessions' in the 1890s, when artists found it necessary to withdraw, or secede, from state or professional control and organise their own exhibitions. In asserting these modern tendencies, artists in Germany were not simply emulating the actions taken by their French counterparts a decade earlier, though the association of their work with 'foreign' elements was one of the decisive factors. These changes were intricately connected to the major historical and political events of the last thirty years of the nineteenth century.

The social and economic implications of a cohesive and undivided German nation have great international resonance, particularly since reunification. It is well to

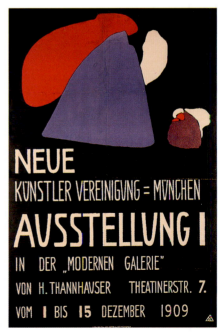

remember that it was as recently as 1871, under Bismarck's foreign policy and at the time of the Franco-Prussian War, that Berlin became the capital of a newly united Germany. The Second German Empire was proclaimed at Versailles with the Hohenzollern King of Prussia, Wilhelm I, being declared Emperor or Kaiser. This initiated what is generally known as the Wilhelmine period, characterised by an unprecedented degree of urbanisation and technical transformation. From 1888 it continued under Wilhelm II until his enforced abdication at the end of the First World War in 1918.

Notwithstanding this declaration of unity, the nation itself consisted technically of twenty-five separate areas (fig.4) – four kingdoms, six grand-duchies, five duchies, six principalities, three free cities and the imperial territory of Alsace-Lorraine. Despite Prussian military dominance, a relatively

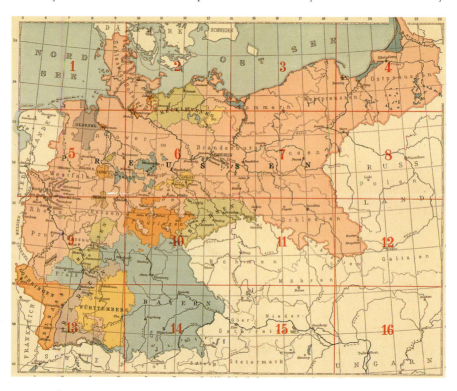

high degree of local power remained in the hands of the individual states. This becomes significant in relation to the ways in which regional differences were manifested in the arts. In Bavaria, for instance, the Wittelsbach monarchy was less authoritarian in its approach to culture than the Hohenzollerns in Prussia; hence it is understandable that Munich preceded Berlin in establishing a secession organisation in 1892. Indeed, as early as 1868, the Union of Munich Artists was given control, independently of the Academy, of arranging the quadrennial Salons. The Hohenzollerns, however, took a close interest in the Academy, the Royal Institute of Fine Arts, and the Association of Berlin Artists the Verein Berliner Künstler. They felt the need to convey a positive public and international image of a unified nation through the official promotion of a national German art.

Such aspirations became more prevalent during the 1890s when Wilhelm II initiated a series of commissions calculated to convey that any art which was in any sense politically relevant – above all monuments, historical paintings and the design and decoration of public buildings – must convey a message of national loyalty and pride. Most telling in this respect is an 1897 photograph of the Cornelius Room in the Berlin National Gallery which shows Ferdinand Keller's painting *Emperor Wilhelm I, the Victorious Founder of the German Empire* 1888 (fig.5) superimposed over the Cornelius cycle, a commission from an earlier, less bombastic phase of the Empire. Keller, a successful academician, was particularly proficient in interpreting recent historical events from the perspective of the ritual and ostentation of a mythological past.

It was to be expected that Wilhelm's personal tastes would come into conflict with museum directors and artists who entertained preoccupations beyond the realm of the official or the academic. Hugo von Tschudi, the director of the Berlin National Gallery between 1896 and 1908, enriched the collection with the works of nineteenth-century French Realists and Impressionists. Although these were largely acquired through bequests and donations, such acquisitions led to open confrontation with the Emperor, making Tschudi's position in Berlin untenable. He was subsequently appointed as head of the Bavarian State Museums in Munich. It was in this climate of suspicion of the 'modern' and 'foreign' that the Berlin Secession was founded.

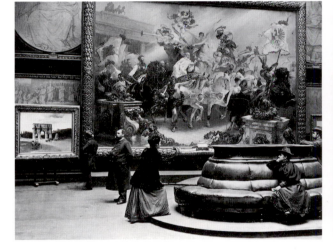

The rejection by the Berlin Salon jury of Walter Leistikow's landscape *Grunewald Lake* (1895) in 1898 was ostensibly the reason for seceding, but dissatisfaction with the inflexibility of the jury system, with academic conservatism and the mass market of the salons, was rife. With the election of Max Liebermann as president, the Secession was headed by a leading figure, well known to the public, who had recently been awarded high official honours. There were various opinions as to what constituted German national identity, and both academician and secessionist alike were involved in these debates. In the catalogue for their first exhibition in 1899, Liebermann declared his commitment to providing a survey of German art, uncluttered and free from parochialism. Evidently, Wilhelm II didn't have sole proprietorship over what was considered to be German.

The youthful art dealers, the brothers Bruno and Paul Cassirer, were appointed joint secretaries of the Berlin Secession, responsible for the management of exhibitions and sales, and for the building of a gallery. The exhibitions, held in a purpose-built venue more reminiscent of the spaces in a private gallery, distanced the Secession from the spectacle and dense displays of

the Salons. The number of artists and works were reduced and the exhibits hung in not more than two rows, amply spaced. The design of the rooms also enabled a stronger concentration on the works: the walls were neutral and sparsely decorated. The choice of subject matter – scenes from everyday life or portrayals of the lower classes, interiors, portraits and landscapes – was the antithesis of the historical events or mythological themes favoured by academic artists. In 1901, Wilhelm II was led to inveigh against this naturalist programme in a speech in which he observed that art should contribute to the education of the broad masses, which it can do only 'if it elevates rather than descends into the gutter'.

Even when the Secessionists depicted acceptable subjects, their treatment of them aroused opposition. The academic style of the 1890s valued a highly finished surface with great attention being paid to achieving illusionism. Works like Lovis Corinth's *Temptation of St Anthony after Flaubert* of 1908 (fig.6), exhibited

5

The Cornelius Room at the National Gallery, Berlin in 1897, featuring Ferdinand Keller's painting *Emperor Wilhelm I, the Victorious Founder of the German Empire*, 1888

Staatliche Museen zu Berlin, Preußischer Kulturbesitz Nationalgalerie

6

Lovis Corinth

Temptation of St Anthony after Gustave Flaubert 1908

Oil on canvas
135.3 × 200.3
(53¼ × 78¾)
Tate Gallery

in the Secession of the same year, obviously did not meet these standards. The composition is extremely artificial, grouped around a focal point containing the elaborate gesture of the beguiling Queen of Sheba, a portrait of Corinth's wife, the artist Charlotte Berend. The other female figures, derived from drawings of studio models, assume unconventional, foreshortened and alarming poses, their contortions conveying heightened erotic states rather than the conventions of restrained and passive beauty. Matching the exoticism of detail – a lithe African male is depicted bearing a Japanese umbrella – colour is applied to emphasise both shape and surface, sending a nervous impressionist flicker of light across the canvas. Indeed, the contemporary critic Alfred Kuhn complained in his monograph on the artist published in 1925 that the work was ambiguous, excessively mannered, and 'at any moment, this laboriously constructed composition might disintegrate and . . . collapse into chaos'.

In its subversive attack on idealism, this painting conforms to the aspects of contemporary German painting that were being heavily criticised by commentators such as the physician and dilettante art historian, Max Nordau. In his book entitled *Entartung* (Degeneracy), published in two volumes between 1892 and 1893 and translated into English by 1895, Nordau employed terminology evolved within the legal and medical disciplines, equating modern stylistic tendencies with criminality and hysteria. Moreover, he condemned the elite and educated middle-class viewers who aped Parisian fashions by yearning for this type of aesthetic pleasure, phenomenalism and depravity. Notwithstanding Corinth's attempts to conform to standards of traditional narrative painting, the work was more suited to semi-private viewing, to a liberal bourgeois audience in contrast to a public salon.

As the historian David Blackbourn illuminatingly sets out in his

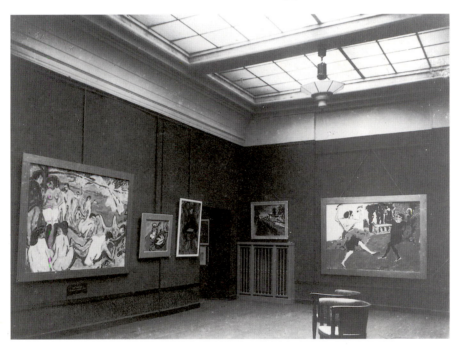

7

Brücke installation at the Galerie Ernst Arnold, Dresden in 1910

8

Ernst Ludwig Kirchner

Bathers at Moritzburg
1909, reworked 1926

Oil on canvas
151.1 x 199.7
(59½ × 78½)
Tate Gallery

introduction to the anthology *The German Bourgeoisie*, the number of entrepreneurs and businessmen rapidly expanded as industrialisation took hold in the latter part of the nineteenth century. He also reveals that both the affluent and educated middle class shared interests in the realm of cultural and social identity. Women's increasing emergence into public life, and their role as consumers, was also crucial to the positive reception of modern art. The expansion of private galleries in Berlin during this period pointed to the rising political and commercial status of the city and catered for the interests of this burgeoning clientele, already familiar with developments in Paris. Despite monarchical dissent, as Robert Jensen says, 'elitism came to constitute the banner of artistic reform'.

It was this 'public' outlined above – enlightened museum directors, private dealers and patrons – that constituted the audience for early Expressionism.

The artists, marginalised from state and professional organisations, needed to band together to search for exhibiting outlets in order to achieve a viable means of existence. After an initial period of extensive self-promotion among private collectors, and of exhibiting in regional association exhibitions in Saxony, the group of artists known as the Brücke received recognition by leading dealers in modern French art in Dresden. For example, if we examine the installation at the Gallery Ernst Arnold in September 1910 (fig.7) of Ernst Ludwig Kirchner's work *Bathers at Moritzburg* (fig.8), started just one year after Corinth's *Temptation of St Anthony,* we notice the hallmarks of modern methods of display and marketing. The paintings are simply framed, well spaced against a neutral

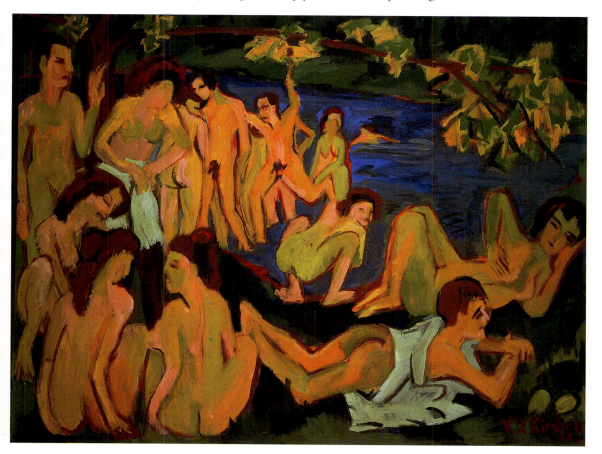

background, allowing for close and intimate scrutiny in an uncluttered, stylish interior. The work itself is of comparable dimensions to the Corinth, Kirchner apparently tackling three identically sized major canvases at the time. Considered a pivotal work, it similarly focuses on a staged scenario of male and female nudity, a subject that was of equal significance in academic, secessionist and avant-garde circles alike. But there the similarities end.

Kirchner models his painting both on drawings based on the community of artists' leisure excursions to the Moritzburg lakes on the outskirts of Dresden, and on the bathers of Cézanne, whose works he had viewed in an exhibition at Paul Cassirer's gallery in Berlin in November 1909. Though the canvas was

reworked by Kirchner during the 1920s, it is evident from X-ray photographs that he initially abandoned, at one and the same time, the tonalities of Corinth's neutralised Impressionism and the painterly modulations of Cézanne's hatched strokes. Instead he contrasted crudely applied yellow-orange areas with the cobalt blue of the water, bringing the fleshy colours and uninhibited nudity provocatively close to the viewer. In an updating of the *Dejeuner sur l'herbe* theme — the installation photograph reveals that the original composition contained a clothed male on the left-hand side and further still-life objects on the lower right — Kirchner declared his distance even from

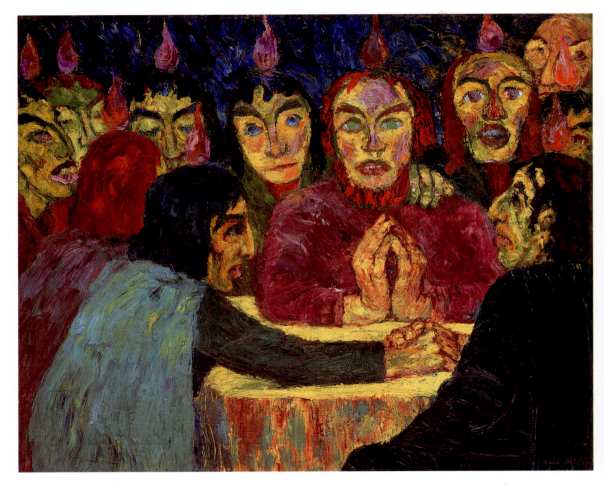

Fauvist renderings of the bather theme.

It is instructive, therefore, that in May 1910, Kirchner participated with other members of the Brücke in a rebellion against the Berlin Secession when the works of twenty-seven artists were rejected by the jury for the Secession's twentieth exhibition. Of these, Emil Nolde's religious painting *Pentecost* (fig.9) was the most controversial. The stylised faces and gestures of Christ and the apostles were compressed into a shallow space, the disturbing, symbolic colours and passionate brushstrokes upsetting the sensibilities of Liebermann in particular. Led by Pechstein, the rebels founded the Neue Secession (New

Secession), signifying their avant-garde status in opposition to the Secession's lack of tolerance towards new members and its growing conservatism. Pechstein's poster (fig.10), advertising the first exhibition held at the private gallery of Maximilian Macht, is handled in a primitivist manner, the portrayal of the female nude bearing a bow and arrow indicating their new aesthetic preoccupations with the tribal art of Oceania and Africa.

Evidently, even the Secession had become incapable of catering for the technical radicalism of the avant-garde. Nonetheless, it served a vital role in offering an arena in which artistic pluralism could co-exist with more traditional values. As we have seen in the case of the twenty-second Berlin exhibition, the Secession continued to be a forum for the display of French contemporary painting, notwithstanding xenophobic outbursts against the collecting and importation of foreign works. In 1911 these attacks reached a climax in the publication of Carl Vinnen's *Ein Protest deutscher Künstler* (A Protest by German Artists). Vinnen, a former landscapist of the Worpswede school, railed against the acquisition of inferior French works and the inflation of the art market, together with the corruptive influence of this on German culture.

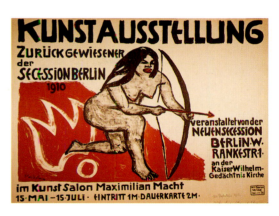

This forced the supporters of early modernism, among them many Expressionist artists, to frame a response. In their reply, they closed ranks with museum directors and dealers in defining the benefits of internationalism to German art and society.

In its alignment with the anti-naturalistic tendencies of 'foreign' modern art, Expressionism was firmly embroiled in the cultural politics of the Wilhelmine period. As the art historian Reinhold Heller has observed, the rapid changes that overtook the patterns of artistic training, production and display during the Imperial era appeared to echo the transformations brought about by technical modernity in the social, economic and political spheres. Vinnen's attack on the international art market revealed a conservative and anti-semitic streak in associating 'foreignness' with urban cosmopolitanism. In the chapters that outline the development of Expressionism prior to 1914, the text will explore these conflicts as revealed in the cultural criticism of the period – the tensions between urban and rural, town and country, *Zivilisation* and nature.

9
Emil Nolde

Pentecost 1909

Oil on canvas
87 × 107 (34¼ × 42)
Staatliche Museen zu
Berlin, Preußischer
Kulturbesitz
Nationalgalerie

10
Max Pechstein

Poster for the Neue
Secession Exhibition
1910 at the Maximilian
Macht Gallery

Colour lithograph
69.5 × 93 (27½ × 36¾)
Brücke-Museum, Berlin

I

NATURE, CULTURE AND MODERNITY: DRESDEN

On 7 June 1905, the four founder members of the Künstlergruppe Brücke (Artists' Group Bridge), Fritz Bleyl, Erich Heckel, Kirchner and Karl Schmidt-Rottluff, committed themselves to functioning as a communal group of artists. This was documented in a pen-and-ink drawing by Kirchner, the motif of the bridge, according to an interview with Heckel in 1958, deriving from Schmidt-Rottluff's suggestion that it led from 'one shore to another'. An official programme, circulated in September 1906, clarified their aims as follows:

> With a belief in continuing evolution, in a new generation of creators as well as appreciators, we call together all youth. And as youth that is carrying the future, we intend to obtain freedom of movement and of life for ourselves in opposition to older, well-established powers. Whoever renders directly and authentically that which impels him to create is one of us.

In emphasising the need for a new generation of 'creators as well as appreciators', the Brücke artists revealed both their avant-garde credentials and their attempt to gain a foothold in a competitive art market. By this time their organisation was listed in the German address book of artists and art associations, their purpose being recorded as the arrangement of exhibitions of modern art. Among other artists who were admitted to the rank of 'active members' were Max Pechstein in 1906, Emil Nolde between 1906 and 1907, and Otto Mueller in 1910. Furthermore, from the start, they set about recruiting private patrons, called 'passiven Mitgliedern' (passive members), who were to

remain long-standing supporters and promoters of Expressionism well after the disbanding of the group in Berlin in 1913.

Of primary significance in the Brücke programme was the securing of freedom from traditionalism in order to create art with 'directness' and 'authenticity'. As we have seen, Nietzsche's emphasis on personal expression had a momentous impact on Expressionist writers, artists and poets. So enthused were the Brücke with his writings *Thus Spake Zarathustra* of 1892 and *Will to Power* published posthumously in 1906 that Heckel made a woodcut print devoted to the likeness of the philosopher. Possibly modelled after a photograph of 1899, Heckel starkly contrasted the silhouettes of black and white in order to convey the intensity of Nietzsche's mental powers and piercing gaze.

The Brücke artists were determined to make an intuitive and 'unskilled' statement through their art. Though many commentators have viewed this as a virtue made out of their lack of training in the fine arts, it is difficult to sustain such an argument in light of evidence to the contrary. As architectural students at the Technical College, as Peter Lasko has confirmed, they would have had the benefit both of exposure to traditional artistic values and of the changes triggered by educational reform in the visual and environmental arts during this period.

Following William Morris's rejection of the mechanisation brought about by the industrial revolution, representatives of the German Arts and Crafts movement condemned both historicist styles and the effects of the standardisation that had dominated production since German Unification. Appropriately labelled Jugendstil or Youth Style, the Applied Arts movement advised a return to the hand crafts, and emphasized the need to imbue the decorative and environmental arts with the organic rhythms observed in nature.

In the main, the emphasis on a renewed engagement with nature was engendered by the pace of urbanisation in the late nineteenth century, which was perceived by many intellectuals to have corrupted civilisation and to have introduced a false set of national values. Cultural criticism, known in German as *Kulturkritik*, aimed to revive pre-industrial notions of community and to instil German identity with renewed spirituality. One such reformer who had an immense impact on artists of his day was Dr Julius Langbehn, whose book *Rembrandt als Erzieher* (Rembrandt as Educator) of 1890 denounced the degenerate features of city life, of science and rationalism.

Notwithstanding the right-wing, conservative elements of his book, Langbehn's message captured the imagination of early Expressionists. They rejected the constraints of German society and institutions, subscribing instead to utopian ideals of communal practice. In pursuing new and modern subject matter, the Brücke artists alternated between their studio located in a working-class district of Dresden, and leisure retreats like the nearby Moritzburg Lakes or the Dangast Moors on the North Sea coast.

This was not a 'return to nature' in the timeless sense of the concept. 'Nature' became inflected with contemporary associations as their works evoked the current trends of modern life. While their urban scenes focused on industrial expansion and the commercial and entertainment outlets of the

town, their rural landscapes made references to debates on the values of outdoor living and nude bathing. For the Brücke, too, the depiction of frank and open sexuality was in line with their interpretation of 'natural' as opposed to 'artificial' relations between the sexes. The female nude and the erotic overtones in the interaction between artist and model featured prominently in their depictions of the studio interior.

The artists were inspired by the dictates of Jugendstil, and they decorated their studios with primitivist craftwork influenced by the tribal art they encountered in the Dresden Ethnographic Museum. At the close of the nineteenth century, Germany evinced a resurgent interest in colonial expansion and acquired possessions in South-West Africa and in New Guinea, receiving the Palau Islands from Spain in 1899. The nation attempted to promote its own centrality by sponsoring World Fairs and by increasing the range of its ethnographic collections in major cities. The bohemian studios of Brücke artists served as the site where such models of 'nature' and 'authenticity', alternative to western traditions, could be aligned with images of modern young women and girls. They attempted to match these interweaving themes of nature and modernity with a rigorous exploration of various media and techniques, from drawing and painting through to printmaking and craftwork.

INSIDE THE STUDIO: TOWARDS 'AUTHENTIC' PRACTICE

In his *Chronik KG Brücke* or *Chronicle of the Artists' Group Brücke* written in 1913, Kirchner characterised the early years of their studio practice as follows:

> Here [in the studio] there existed the opportunity to study the nude, the foundation of all pictorial art, in free and natural motion. From our drawings according to this foundation there developed a communal sense that we should derive the inspiration for our work from life itself and should subordinate [ourselves] to its direct experience.

While many aspects of Kirchner's narrative were rejected by other members of the group when it disbanded in 1913, this passage is regarded as entirely reliable. The significance he associated with the study of the nude as the 'foundation of all pictorial art' and as the 'matter' that bound the group in communal practice can be corroborated by the predominance of the motif within their respective *oeuvres*. What differentiated Brücke artists' procedures from traditional standards will be explored below, as will the conclusion that it was from the principle of study of the nude that they were inspired to derive their work from 'direct experience' of life. Their studio activities also involved an exploration of graphic processes which, though traditionally ascribed to the sphere of the manual arts, became invested by the Brücke with values of authenticity and high art. From the start, the possibility of editions of prints was exploited as a worthy method of reaching a broader public.

The seriousness with which they regarded communal practice can be ascertained from Schmidt-Rottluff's woodcut *The Studio* of 1905. An atmosphere of concentration pervades the interior lit by paraffin-lamps, as the group of artists at easels, accompanied by other young architect colleagues, focuses on an unseen model. Until Kirchner occupied a ground floor studio at 60 Berlinerstraße, Friedrichstadt, in 1907, the attic of Heckel's parent's residence in 65 Berlinerstraße served as their joint venue. Here, in the oldest

11
Fritz Bleyl

Woman Nude 1905–6
Pencil on paper
44.7 × 34.3
(17½ × 13½)
Brücke-Museum, Berlin

12
Karl Schmidt-Rottluff

Crouching Nude 1905

Oil on board 71 × 57
(28 × 22½)
Brücke-Museum, Berlin

working-class suburb in the south of Dresden, they held evening life-classes, having sought out an amateur model, a young woman of fifteen years old known as Isabella. She took up different and informal poses for no longer than fifteen minutes at a time, a routine that escaped associations with academic practice. As Bleyl's blocked-in drawings (fig.11) from these sessions demonstrate, he intentionally distanced himself from his student works in adopting rapidly applied contour and almost scribbled-in tonal areas that

captured the unexpected and transitory appearance of the casual poses.

In sketchily painted works from these life-classes, such as Schmidt-Rottluff's *Crouching Nude* of 1905 (fig.12), it is evident that Brücke artists were familiar with the paintings of van Gogh. A large exhibition of his works, held in November 1905 at the Gallery Ernst Arnold in Dresden, had a notable impact on their practice. Following van Gogh's example, Schmidt-Rottluff adopted a vehement and textured brushstroke that enlivened the surface of both figure and ground. The structure of the female nude is almost lost in this turbulence and in the equal intensity of the colour range – a pastel palette of flesh-pink, yellow and white, with earthy mixtures for emphasis. Schmidt-Rottluff applied paint directly over a summary drawing, indicating that it was desirable to expose the process and to retain the unfinished appearance of the work. It was a departure from the elaborate academic practice of making numerous drawings and coloured studies in preparation for the final work.

The image of the model Isabella was used again as the point of departure for the promotional poster for the first major Brücke group exhibition in September 1906, a lithograph by Bleyl (fig.13). The exhibition was held in the showroom of a lamp and lighting factory belonging to the businessman Karl-Max Seifert, situated in the industrial area of Dresden-Lobtau. According to Bleyl's reminiscences, permission for public display of the poster was denied by the police on account of the portrayal of frank nudity and the exposed pubic hair of the figure. These features, and the sensual curves of the body mounted on a plinth as though a monument, must have struck the uninformed viewer as either incongruous or subversive, too much like 'nature' for its apparent function. This inaugural exhibition, comprised of paintings, watercolours, woodcuts and etchings, received little critical attention due to the marginality of its venue. In what

must be a rare instance, for the time, of avant-garde collaboration with private industry, Brücke works competed with modern consumer items for attention.

The preponderance of graphic works in this exhibition indicates the importance attached by Brücke artists to exploring various media within their studio practice. Graphic reproduction in the nineteenth century was a protected occupation, undertaken by highly skilled professionals in workshops. However, by the early twentieth century the activity became invested with notions of individuality, as artists increasingly undertook their own preparation and printing of graphics. Indeed Kirchner stated as much in an intended supplement to his *Chronicle* of 1913 entitled 'Concerning Graphics'. The fundamental motivation he proclaimed lies in:

> The attraction of translating the manual aspects of the creative personality into the mechanical … By printing by hand it is possible to carry out all three techniques [woodcut, lithography and engraving] in the studio and also to place the final technical refinements into the hands of the creator.

Exploiting the current emphasis by the Jugendstil on hand craft in the face of the erosion of this principle by mechanisation, Brücke artists focused, in particular, on the expressive potential of woodcuts. In this, they also responded to the urgings of cultural reformers by recovering an 'authentic' lineage in German medieval and early Renaissance prototypes, such as Dürer and Cranach. As Kirchner recalled in his *Chronicle*, it was during his trip to southern Bavaria in 1903 that he admired the artisan values of old German woodblocks displayed in Nuremberg.

In Kirchner's woodcuts of 1905 to 1906, as with those of the other members of the group, the style is inspired by illustrations in Arts and Crafts journals such as *Studio* or *Jugend*, Japanese prints and the works of the Swiss-French artist Felix Valloton. Kirchner's print depicting Isabella, *Half-Nude in the Student Room* (fig.14), relies on a dominant use of contour and the opposition of areas of black and white without the intervention of halftones. However, in providing details of the room as combined studio and living quarters, this portrayal has nuances beyond the study of the model in a life-class. Caught in the process of robing or disrobing, the partially clothed young woman reveals an awareness of her nudity suggestive of a more intimate relationship with the artist.

Pechstein, who trained both at the Applied Arts School and the Academy in Dresden, was well versed in the practice of wood engraving which had been widespread in the nineteenth century for book and magazine illustration. Once he joined the Brücke group in 1906, he switched to the technique of carving the

woodblocks. As can be seen in his advertising card for the second Brücke exhibition held at Seifert's premises in December 1906 (fig.15), devoted solely to the display of woodcuts, Pechstein roughly gouged out the background of the wood, contrasting these directional textures with a distorted treatment of the head, ringed by a halo. At this time, the Brücke greatly admired the woodcuts of the Norwegian Edvard Munch, inviting him to contribute prints to this exhibition and to become an active member of the group. Pechstein's interest in the expressive and anti-illustrative potential of the medium was certainly encouraged by Munch's example.

By 1909, however, contact with the tribal art of Oceania and Africa significantly informed Brücke's practice. They were familiar with Gauguin's quest for past simplicity in the distant setting of Tahiti. Indeed, both Nolde and Pechstein followed in Gauguin's footsteps by undertaking separate journeys to German colonies in the South Seas in 1914. As with other modernists, like Matisse and Picasso, the Brücke regarded the so-called 'untutored' aspects of what was then called primitive art as positive virtues. Invariably though, artists of the early twentieth century, subjected to the Darwinian prejudices of the period, viewed the makers of this art as frozen within the 'childhood' or 'dawn of humanity' and paid scant attention to the diverse origins and functions of the works which they used as sources.

This can be gauged from photographs of the interior decor of Kirchner's studio at 80 Berlinerstraße which he rented from November 1909 (fig.16). The

living area contained wall hangings made of bed linen which were painted with stylised landscape and figural motifs. The poses of the figures, the strong contours, and the shallow, frieze-like composition were inspired by Palau roof beams encountered in the Dresden Ethnographic Museum (fig.17). Acquired by the museum in 1881 from the collection of Karl Semper, who visited the Islands in 1862, these beams portray scenes from the daily life and mythology of the area. Kirchner seized on the erotic suggestiveness of the figures, arranging them into compositions that overtly depict sexual foreplay and intercourse. Elsewhere, in strongly coloured roundels painted on curtains separating the rooms, silhouetted couples are portrayed enacting uninhibited love-making. But, as Jill Lloyd has shown, these images probably derive from Buddhist carvings on temple doorways in Ajanta illustrated in John Griffith's book of 1896, a text that Heckel obtained from the Dresden Central Library in 1908.

Whether of tribal, Eastern or African origin, these 'primitive' sources were all recruited to support the aspirations of the Brücke, who sought to effect an equation between art and life. Within the privacy of the studio, they could resist the moral constraints of Wilhelmine society by evoking in their

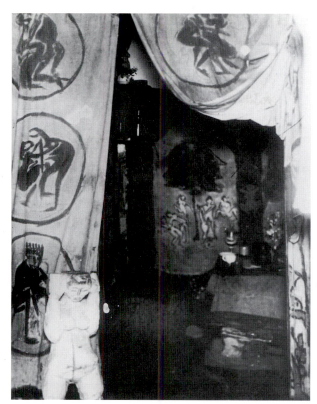

surroundings the primitivist union of the sexes in nature. At this time, apart from Kirchner's partner, the dancer Doris (Dodo) Grohse, the two daughters of a Dresden artist's widow, Fränzi and Marcella, served as models in the studio and in the Brücke's landscapes with figures. The presumed innocence of childhood and their unselfconscious body language were relevant to artists who desired to be liberated from artificial conventions.

Heckel's woodcut *Standing Child (Fränzi)* of 1911 (fig.18), also owes its severe two dimensionality, its scratched, angular carving and coloured surfaces to the inspiration of the Palau roofbeams. Here, he subtly adapted these formal characteristics to the gaunt body of the young adolescent, whose facial features are simplified in emulation of a tribal mask. The child/model is viewed against the verdant green hills and red sky of Heckel's decorative scheme, begun between 1910 and 1911, for his recently acquired studio. Evidently, primitivised images of women and young girls served as suitable metaphors of 'nature' in these contrived urban interiors.

This print formed part of a series of three included in a portfolio of 1911 dedicated to Heckel's graphics. In the spirit of communal practice, however, a woodcut designed by Pechstein provided a frontispiece for the collection. Despite being one of an edition, each impression had its own uniqueness as a manifestation of the artist's hand and personality. These portfolios, or *Jahresmappen*, were published between 1906 and 1912. In the absence of arrangements with dealers, the Brücke artists functioned as their own printers and publishers. In return for a subscription (which started at 12 marks and later increased to 25 marks), 'passive members' received a membership card, an annual portfolio and annual report.

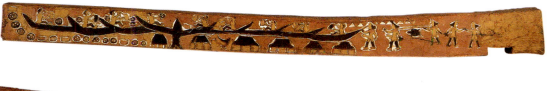

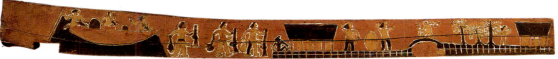

The list of passive members was recorded by Kirchner in woodcut prints that facilitate an identification of the range of supporters drawn from the affluent and professional middle class. We have already encountered the name of the factory owner Karl-Max Seifert listed as residing in Dresden. Also entered was the district judge from Hamburg, Gustav Schiefler, a dedicated cataloguer of contemporary original graphics, who introduced the Brücke to the prints of Munch. In 1907, the art historian and critic Dr Rosa Schapire was recruited, who became a notable patron and collector of the works of Schmidt-Rottluff. By such networking, the Brücke trod a fine line between avant-garde practice and private patronage, as well as securing recognition by exhibiting in the galleries of Emil Richter between 1907 and 1909 and Ernst Arnold in 1910 in Dresden. In this period, the art of the Brücke reached maturity and will be surveyed in the next section. The themes of nature and modernity are suitable categories in which to explore their urban and rural subject matter.

BETWEEN TOWN AND COUNTRY (1909–1911)

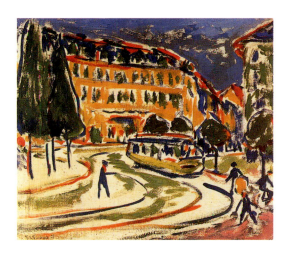

18
Erich Heckel

Standing Child (Fränzi)
1911

Coloured woodcut
37.5 × 24.8 (14¾ × 9¾)
Brücke-Museum, Berlin

19
Ernst Ludwig Kirchner

Streetcar in Dresden
1909

Oil on canvas
69.7 × 78.5
(27⅛ × 31)
Collection of Dr Max
Fischer, Stuttgart

By the turn of the century Dresden was a large provincial town of about 700,000 which, despite a fifty percent population increase since 1885, remained largely untouched by heavy industry. The magnificent skyline hovering on the banks of the Elbe served as an inspiration for generations of landscapists. It was not without reason that the town earned the reputation of the label 'Florence on the Elbe', before the fire-bombing and destruction of 1945. Inevitably, both Bleyl and Kirchner paid homage to the famous view in sketches that recorded the curved river bank forefronting the monumental Augustus bridge and skyline. In their different ways, both artists focused on the manner in which the Elbe served as a leisure outlet for bathing and boating, making the structures and domes of the town centre seem part of nature. More frequently, however, their outdoor sketches related to the less marketable environs of their studio, where they were attracted to the stark modernity of the nearby steel bridges, rail tracks and factories that abutted the high-rise residential blocks.

Their work of 1909 reflects an awareness of avant-garde developments in Paris. Not only did Pechstein undertake an extended visit there in 1908, but also the Fauve group were exhibited contemporaneously with the Brücke in September at the Gallery Emil Richter in Dresden. In Kirchner's painting *Streetcar in Dresden* (fig.19), the tracks are depicted meandering organically through a tree and apartment-lined street, as Kirchner simplified the compositional structure by using discontinuous ultramarine and vermilion contours. The paint

is applied spontaneously, allowing the primed canvas to emerge and dominate the surface. Seizing on Matisse's Fauvist palette of 1905 to 1907 – a combination of red, green, yellow and blue – Kirchner heightened the urgency of the colouration by adding an area of pink in the lower right-hand corner. All in all, he celebrates the public spaces of modern life, which at this stage appear to offer little threat to the stick-like figures of the pedestrians and cyclists.

This applies equally to the scenes of popular entertainment that became prevalent in Kirchner's *oeuvre* from 1908 onwards, particularly after Pechstein's return from Paris. For the exotic spectacle depicted in *Japanese Theatre* 1909 (Scottish National Gallery of Modern Art, Edinburgh), Kirchner selected a similar intensity of palette to the concurrent urban landscapes, though the colour areas are denser and the impact more saturated. Baudelaire's theory of modernity, in which the artist is urged to be a person of their time, was

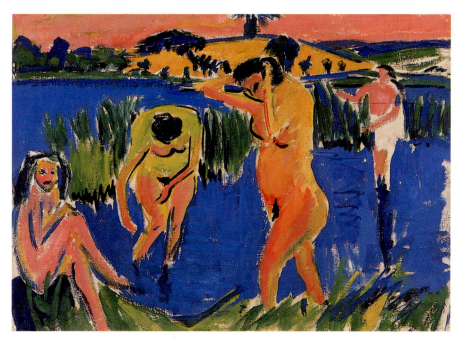

evidently keenly embraced, as Kirchner overtly referred to the Brücke's association with the world of dancers, prostitutes and performers who were often the subject of their works. The dance, as a symbol of natural energy, of Dionysian release, was developed into a vividly forceful theme. In the Brücke exhibition held at the Gallery Ernst Arnold in 1910, the pride of position given to Pechstein's canvas *Dance* of 1909 (Brücke Museum, Berlin) was equivalent to that of Kirchner's *Bathers at Moritzburg*.

It seems therefore that the Brücke did not heighten the tensions between town and country at this stage but tended to naturalise those experiences of the urban milieu to which they were attracted. Clearly, the most significant collaboration was their communal work at the Moritzburg Lakes in the summers of 1909 to 1911, when female bathers and mixed bathing groups appeared in paintings by Kirchner, Heckel and Pechstein. The importance of the outskirts of Dresden, with its expanding network of sanatoriums and

health resorts, as a centre for outdoor bathing, nature cures and body culture, has been well established. The popularity of the area increased markedly in the early 1900s so that it was necessary to publish a guidebook, *Köhler's Tourist Guide*, which appeared in 1909. It was no coincidence therefore that the Brücke developed their ideas about sexual freedom and anti-bourgeois life styles within this environment.

Yet sexual segregation was almost universally practised in nudist colonies and it was necessary to evade the more established centres on the lakes in order to indulge in mixed nude bathing. Pechstein's recollections that they were admonished by local policemen when attempting to do so is borne out by their efforts to reach remoter, less accessible islands within the lakes. With graphic and playful precision, Heckel's etchings of 1911, *Throwing Reed Arrows* and *Wading through the Water* (both in Museum Folkwang, Essen), would appear to be based on efforts to locate just such a sanctuary.

Kirchner's painting *Four Bathers* of 1910 (fig.20) similarly places the protagonists in a horizontally defined terrain, the tall reed banks of which provided both seclusion and recreation. This work encapsulates the Expressionist features of this phase in Dresden and, in that it escaped being later reworked by the artist, discloses much about his creative process. Though the canvas may have been retouched, it appears as though painted directly in one session without preparatory drawing on the surface. While two of the female bathers are recognisable as Fränzi on the left and Kirchner's partner Doris, situated in the centre with her hands raised to the head, the figures are generalised, composed in a frieze-like arrangement reminiscent of the Palau carvings. The bodies are similarly primitivised, the profile of Dodo, with its protruding buttocks, being invested with the stereotype of femininity derived from African tribal carving. The flesh takes on the appearance of almost bronzed colour in contrast to the intense blue of the water and green of the reeds, the distant shore line, surmounted by a flesh-coloured sky, echoing the intensity of the foreground.

The technical radicalism of Kirchner and the other members of the Brücke soon differentiated their work from Jugendstil, with its decorative overtones, as well as from the naturalism of *plein-airism*. Though informed by the legacy of Cézanne's monumental bather compositions, and by Fauvist devices, the themes of nature were defined by debates specific to the Brücke's experiences of modernity in early twentieth-century Germany. They counteracted the threat of a tired, replete civilisation by seeking cultural renewal through what was in fact a misinformed interpretation of what constituted authenticity in non-European traditions. With this matching of medium and process to theory, the Brücke programme appeared fully developed before the group moved to Berlin. This move was brought about primarily by Pechstein's relocation there in late 1908. He initially encountered acceptance within the existing structures of the Berlin Secession and made promising contact with private dealers. While Bleyl had already left the group in 1909 to focus on his teaching, Kirchner, Heckel and Schmidt-Rottluff left Dresden during 1911. Before focusing on their reception and careers in a new context, it is necessary to consider the development of Expressionist theory and practice in Munich in the period up to 1912.

20
Ernst Ludwig Kirchner
Four Bathers 1910
Oil on canvas
75 × 100.5
(29½ × 39¾)
Von der Heydt-Museum, Wuppertal

2

UTOPIANISM AND ABSTRACTION: MUNICH

A rival to Berlin as an artistic centre, Munich held many attractions as a place to
study art. The important position of the visual arts in the city was a well
established phenomenon, achieved through the patronage both of the Catholic
church and the monarchy in Bavaria. By the mid-nineteenth century, an urban
renewal scheme sponsored by King Ludwig I led to the opening of the first
public museums of their kind in Germany. These were devoted to the housing
of the Wittelsbach monarchy's private collections, and ranged from the
Glyptothek for antiquities to the Neue Pinakothek for art produced after 1800.
The city also boasted the highly rated teaching institution of the Academy of
Fine Arts and, by the 1890s, the lucrative workshops of the so-called *Malerfürsten*
or painter princes, Franz von Lenbach and Franz von Stuck.

Compared to Berlin, Munich had a greater availability of exhibiting space;
the Glaspalast (Glass Palace), built in 1854 in emulation of London's Crystal
Palace of 1851, was the venue for the massive quadrennial salons that featured
the works of German and foreign artists. Reacting against the populist appeal
of the salons, the Munich Secession, founded in 1892, dedicated itself to
attracting a more select audience to the elegant interior of their purpose-built
gallery in Prinzregentenstraße. The Secession exhibited Symbolist art and a
mood-evoking, lyrical form of landscape, but it also played a pivotal role in the
dissemination of Jugendstil. Examples were the modern interiors designed by
Henry van de Velde and Fritz Erler shown at the summer exhibition of 1899.

These impressive structures of artistic training and display, added to
Munich's relative proximity to Paris and Central Europe, attracted many

aspiring artists from America, Scandinavia, Russia and Poland. In 1896, the Russian Wassily Kandinsky, at the age of thirty, turned down the offer of an academic appointment in Russia in order to pursue an artistic career in Munich. Kandinsky had specialist training in Russian peasant law and ethnography, which was to prove of enduring significance to his artistic development. In his *Reminiscences*, published in 1913, he vividly recalled his field trip to the remote province of Vologda in 1889 which had a marked influence on him. Both this, and his evocative descriptions of Rembrandt's paintings, Monet's *Haystacks* and Wagner's *Lohengrin*, indicate that he was a person of great intellectual breadth, who brought these various interests to bear on his later theoretical formulations. In the main, his treatises promoted abstraction and denounced the materialism of the modern age, stressing the need to invest art with a new spiritual direction.

Kandinsky was not alone in his choice of Munich as a base. Many of his compatriots, among them Vladimir von Bechtejeff, Alexej Jawlensky and Marianne Werefkin, decided to settle there. Werefkin was a private student of the realist Ilja Repin before attending the Moscow Academy between 1883 and 1886. In 1891 she accompanied her father, a general in the infantry, to St Petersburg where she met the artist Jawlensky, then a lieutenant in the St Petersburg regiment. When her father died in 1896, Werefkin received an inheritance which enabled her to move to Munich. Here she joined Jawlensky and, for a decade, she stopped painting and dedicated herself to promoting his career.

Playing the role of muse, lover and supporter of his talent, she carefully scripted the drama of their life together. She founded the St Luke Artists' Association which held meetings at her residence in 23 Giselastraße, Schwabing, the artists' quarter of the city. Werefkin was the older partner, providing both economic support and intellectual directives for her erring and more intuitive male partner. Her journals, *Lettres à un Inconnu* (Letters to an Unknown), written between 1901 and 1905, offer an insight into the vicarious nature of her relationship with Jawlensky and into her theoretical preoccupations. Although Werefkin sponsored radical theories of abstraction, her *oeuvre* retained a paradoxical engagement with realist subject matter. Jawlensky, however, established contact with Matisse's circle in Paris and bridged the gap between Fauvism and Munich-based Expressionism.

Kandinsky also settled in Schwabing and made contact with his fellow expatriates during these early years in Munich. Married at the time, he formed an intense relationship with his student, Gabriele Münter, eleven years his junior, which lasted from 1902 until 1916. In 1909, their contact with Werefkin and Jawlensky solidified into a communal identity. Along with German and other foreign artists, they founded the avant-garde exhibiting group the Neue Künstlervereinigung München (Munich New Artists' Association or NKV). In late 1911, following various disagreements, Kandinsky, Münter, Franz Marc and Alfred Kubin seceded from the NKV to form the Blaue Reiter (the Blue Rider). Werefkin and Jawlensky joined them a year later but the group was effectively disrupted by the outbreak of the First World War in 1914.

While the nucleus of the 'active members' of the Brücke was specifically

German and male, the make-up of the Munich-based association was cosmopolitan and open to the membership of women practitioners. Barred from entry to academies in Germany, women artists followed the fundamentals of male avant-garde practice – a rejection of traditional training and an adoption of the lesser genres of landscape, still-life, portraiture and interiors as vehicles for exploring innovative aesthetic values. The significance attributed to landscape painting, in particular, suggests that the themes of nature and modernity are relevant to an examination of the work of the NKV and Blaue Reiter.

Between 1908 and 1911, Münter, Kandinsky, Jawlensky and Werefkin alternated between Munich and summer excursions to the village of Murnau in the Bavarian Alps. They sought authenticity both in the surroundings and in the supposed untutored qualities of the region's folk art. Inspired by the utopianism of Jugendstil, they decorated their urban and rural homes with folk art collections deriving from Russia and Germany and donned Bavarian costume to go 'native'. Their paintings, graphics and craftwork combined inspiration from these sources with the language of modernism, the group having gained familiarity with avant-garde developments in Paris. However, the image of the artist that they cultivated was not one of bohemian rebellion, as projected by the Brücke, but of an elite circle, professionally just as at ease seated at a desk as standing before an easel (fig.21).

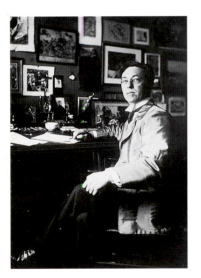

A wide-ranging approach, termed syncretism, characterised the primitivism of the NKV and Blaue Reiter. In the *Blaue Reiter Almanac*, examples of Bavarian and Russian folk art, ethnographic items from Africa and Asia, medieval sculpture, old German prints, Japanese and child art were deemed of equivalent aesthetic quality to Western high art (such as the work of El Greco) and the modern painting of van Gogh, Cézanne and Henri Rousseau. A series of essays on modern art, music and theatre edited by Kandinsky and Marc and published in 1912, the *Almanac* was a milestone in creative collaboration and in the promotion of Expressionist theory.

In comparison to the rhetoric of the Brücke, however, the writings of Kandinsky, Werefkin and Marc were more theoretical and were invested with a greater sense of mysticism. Imbued with the legacies of Romanticism and Symbolism, they questioned the Impressionist depiction of the outer world, substituting for this an art impelled by 'inner necessity'. In this outlook they were informed by the ideas of the German philosopher Arthur Schopenhauer, whose influential treatise *The World as Will and Representation* (1818) maintained that the experiences of the Will (emotions and strivings) were superior to those of Representation (ideas, morals and reason). They argued that art should not be conditioned by observing the sensations of nature, it has its own intrinsic nature, an interplay between the various elements of line, colour and shape.

21

Wassily Kandinsky at his desk in Ainmillerstraße in June 1913, photographed by Gabriele Münter

Städtische Galerie im Lenbachhaus, Munich

The psychological and emotional impact of colour, in particular, was deemed an effective means of reaching the soul of the viewer, comparable to the 'vibrations' of sound reaching a listener's ear. Such concepts of expression, based on the interrelationship between the arts, stem from a complex heritage of ideas, including Baudelaire's evocative poetry, Wagner's operatic theory and the Synthetist tradition of Gauguin. In addition, Kandinsky alluded to esoteric sources, the Theosophists and Rosicrucians, that give insight into the occultist references in his major treatise, *On the Spiritual in Art*, published in 1912.

The artist's pursuit of abstraction was to be as important to Kandinsky as the scientist's quest to understand the hidden workings of the universe. Kandinsky saw the artist as a prophet, seer, or healer of society, and as such invested with the capacity to transform it. It is at this juncture that the ritual and myth of pagan cultures, such as the role of the shaman or sorcerer, become relevant to interpreting the ethnic origins of Kandinsky's quest for cultural reform. His Russian heritage, and identification with the so-called primitive tribes of the Vologda province, informed his modern-day critique of society. Such attitudes were not unique in this context since Russian Symbolists and members of the *Mir Iskusstva* (World of Artists) too, fostered a recovery of the arts and crafts of rural communities so as to preserve such practices from the onslaught of modernisation. The general contention was that, in aspiring to a new spiritual epoch, civilisation could learn much from the values of so-called primitive cultures.

Prior to examining the relationship of theory to practice in Kandinsky, it is important to acknowledge that his move towards abstraction was neither evolutionary nor impulsive but part of a broader context. Kandinsky was uncertain about abstraction, hence the great disparities in the makeup of his *oeuvre* and his need for theoretical justification in response to fierce critical opposition. He never quite abandoned landscape painting and even initiated cityscapes on his return to Moscow during 1916. It is informative, therefore, to consider aspects of his training and professional role as a teacher. This will illuminate why his attempts to abandon the object or to deny the body, provoked such heated debate in the pre-1914 period.

KANDINSKY, TRADITION AND CULTURAL REFORM

When Kandinsky arrived in Munich in 1896, he studied art for two years in the private studio of the Slovenian painter, Anton Azbè, where he met Jawlensky and other Russian students. Subsequently, his strenuous efforts to gain entrance to the Academy strike one as rather surprising, given the circumstances of his age and aspirations. Though he failed in this attempt at first, he was eventually accepted by Franz von Stuck for his masterclass in painting at the Academy.

While extremely gracious in praising his tutors, Kandinsky was dismissive of the academic practice of drawing from the model. Though his *Reminiscences* were written in 1913 and invested with the values of hindsight, his views on this aspect of his training in the studio of Anton Azbè were sufficiently fresh in his

mind. He considered the process a 'constraint' upon his freedom that turned him into a 'slave' and he continued:

> Two or three models 'sat for heads' or 'posed nude'. Students of both sexes and from various countries thronged around these smelly, apathetic, expressionless, characterless natural phenomena, who were paid fifty to seventy pfennigs an hour. They drew carefully on paper or canvas . . . not one second thinking about art.

The references to being enslaved by the model constitute an ironic inversion of the academic artist's mastery or control over the human body. This is accompanied by an unconcealed aversion to the model, the purity of art having little to do with this routine activity in the confines of the studio. Possibly, denying the relevance of the body was a means of ameliorating the artist's discomfort in being controlled by its presence, an issue that will be explored in the section on abstraction.

It is understandable therefore why, apart from in his student sketchbooks, portraiture or paintings of the nude are rare occurrences in Kandinsky's *oeuvre*.

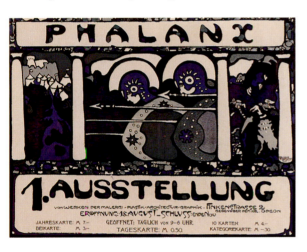

As in traditional practice, however, he retained firm distinctions between his 'paintings', 'oil studies' and 'coloured drawings'. At this time, his developed studio work, painted on large stretched canvases in mixed media, drew on medieval imagery and themes from Old Russia. However, his small oil studies, painted on canvasboard or cardboard, depicted parts of Schwabing or the English Garden in Munich. The paint was applied with the palette knife, directly from the tube or sometimes with the brush. The freedom of painting landscape on the spot provided Kandinsky with the opportunity for modernist experimentation. Indeed visionary landscape was to be the basis for his major abstract compositions between 1909 and 1914.

In 1901 Kandinsky struck out independently by co-founding an exhibiting society known as Phalanx, which also served as a private school, located in rooms near the Secession. Their ideals were summarised in his poster (fig.22) which is in the tradition of Jugendstil in its treatment of forms with characteristic organic outlines. The use of flat planes of bright colour and wilful stylisation of objects also assist in achieving an ornamental effect. Images of knights bearing lances against columns, symbols of tradition, suggest an attacking force or advance guard forging paths for a culturally revitalising movement.

As chair of the Phalanx society, Kandinsky organised exhibitions that were extremely diverse, ranging from members of the Secession to practitioners of

22
Wassily Kandinsky
Poster for the Phalanx
Exhibition 1901
Colour lithograph
47.3 × 60.3
(18⅝ × 23¾)
Städtische Galerie im
Lenbachhaus, Munich

23
Wassily Kandinsky
The Motley Life 1907
Tempera on canvas
130 × 162.5
(51¼ × 64)
Städtische Galerie im
Lenbachhaus, Munich

the applied arts. The courses offered by the school also suggested an erosion of the divisions between fine and applied art, by offering life classes, modelling in clay and plaster, painting and graphic design. It was in his capacity as teacher that Kandinsky first made contact with Gabriele Münter who, inspired by the reformist elements of the Phalanx programme, left her training at the Damen-Akademie (Ladies Academy) of the Künstlerinnen-Verein (Women Artists' Association) after two semesters and enrolled at the Phalanx school in early 1902. Münter attended evening life classes under his guidance and her interest in *plein air* painting was encouraged during excursions to Kochel and Kallmünz in Bavaria. Her transition from student to professional artist was effected

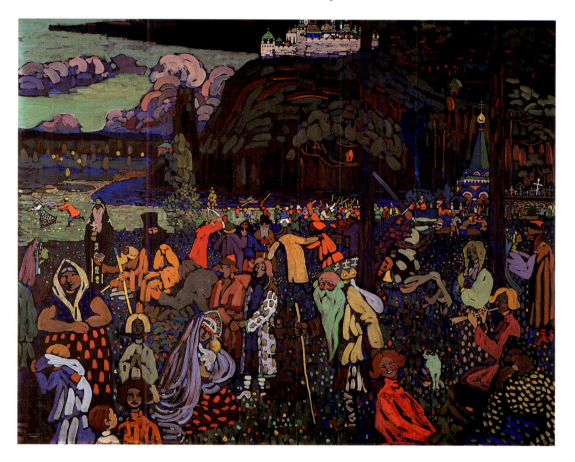

between 1904 and 1907 when she travelled extensively with Kandinsky, before they settled in Sèvres near Paris for a year until June 1907.

Kandinsky's major studio painting produced during this sojourn, *Das bunte Leben* or *The Motley Life* (fig.23), is symptomatic of the richness and diversity of his pre-1914 *œuvre*. Exhibited at the Salon d'automne in 1907, this work was conceived as a form of modern history painting, a contradiction of sorts, since it represents a mythical narrative of Old Russia. The iconography dwelt on Kandinsky's views of the complex make-up of Russian identity — the oppositions of pagan belief and Christianity, peasant and town-folk, order and chaos, joyfulness and conflict. Some motifs derived their authenticity from

Kandinsky's specialist knowledge of and travels in rural Russia; the art historian Peg Weiss has traced the location of the landscape to the market town of Ust Sysolsk, at the confluence of two rivers, apparently the centre of Kandinsky's earlier ethnographic activities. An amphitheatre is created to contain the varied populace, who are portrayed wearing the patterned costume of the local Zyrian peasants. While some images, like the Virgin and Child, derive from Russian Orthodox icons, other motifs, such as the bearded shaman leaning on a stave, or the charging horseman, seem inspired by fairytale illustrations. These eclectic sources are subordinated to a quasi-pointillist technique, applied over a black tempera ground, and sealed with a varnish. Because of their unscientific and rhythmic application, the dots, patches and shapes of colour take on their own independent existence and elude a systematic reading of form and space. Hidden objects, like the depiction of Kandinsky's cat in the right-hand foregound, only become visible after careful scrutiny.

It is difficult to determine whether this enigmatic account of things Russian and of exotic colourism, was a result of private nostalgia or was something Kandinsky considered marketable in the context of the Salon d'Automne. There was a forceful community of Russian expatriates in Paris who exhibited at this event in 1905, which saw the controversial launching of the French group of Fauvists. For this occasion, a Russian pavilion was organised by the impresario Sergej Diaghilev; however Kandinsky didn't affiliate with this group. It was only after the couple's return to Germany that links were established with like-minded artists, who were actively engaged in transforming painting into the more radical, non-naturalistic art associated with Expressionism.

ARTISTIC COLLABORATION: MUNICH AND MURNAU

Resettling in Munich in June 1908, Münter and Kandinsky made excursions to the Staffel lake, near the town of Murnau. They recommended the area to their friends and fellow artists Werefkin and Jawlensky who, after following their advice, enthusiastically invited Kandinsky and Münter to join them in mid-August at the guesthouse Griesbräu. This initiated a period of interaction that involved their testing of the limits of painting within the landscape genre, while intensifying an engagement with notions of primitivism.

Located in the south Bavarian Alps, Murnau was a market town with a predominantly agrarian and Catholic population. Being close to Oberammergau, celebrated for its Passion plays, Murnau was also sought after as a tourist destination, easily reached by train from Munich. That the architectural cohesion of the town was the result of recent modernisation was of little consequence to this group of artists. From their viewpoint, it matched their search for untainted rustic simplicity and piety. Indeed so taken were they with the area, that Münter purchased a property there in 1909, known thereafter as the Russian House, which became a rural retreat for members of the NKV community.

The foursome pursued similar motifs, views from the guesthouse windows, vistas of the Murnau moors and, after 1909, the outlook over the town from

24
Alexej Jawlensky
Summer Evening in Murnau 1908–9
Oil on board
33.2 × 45.1
(12¾ × 17¾)
Städtische Galerie im Lenbachhaus, Munich

25
Wassily Kandinsky
Church in Murnau 1910
Oil on board
64.7 × 50.2
(25½ × 19¾)
Städtische Galerie im Lenbachhaus, Munich

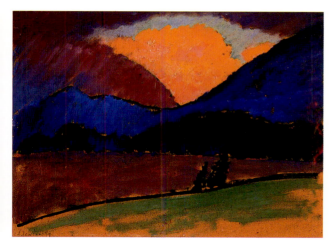

Münter's house. Jawlensky was the most conversant with avant-garde developments in Paris. He had exhibited with the Russian group of artists in the Salon d'automne of 1905 and, during 1907, the Nabis Jan Verkade and Paul Sérusier visited him in Munich. His acquaintance with Synthetist aesthetic theory was updated by a period spent in Matisse's studio in the same year. Hence, in the painting *Summer Evening in Murnau*, of 1908–9 (fig.24), Jawlensky synthesised the outer details of the landscape with his ideas regarding the function of line and colour. As in the cloisonism of the Synthetists, dark contours signal the horizontal planes of the moors, mountain and sky, as well as indicating the boundaries of differently coloured areas. Based on the near complementaries of purple and orange, the colouration is intense, the paint application varying from thin washes on the unprimed strawboard, through to the textured impasto of the blazing sunset.

In his Murnau landscapes, encouraged by Jawlensky's example, Kandinsky

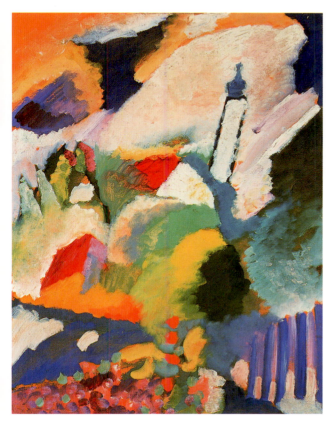

gave up the palette-knife in favour of short-haired brushes and larger, unprimed boards. The scale of *Church in Murnau* (fig.25) indicated that he had come to regard the genre as worthy of a fully worked-up 'painting', rather than a mere 'study'. In this view of the town from Münter's house, Kandinsky undermined any preliminary compositional structure by his versatile brush technique. As a result, the solidity of the objects is denied, and the onion-domed tower of the Maria-Hilfe Church hovers on the two-dimensional plane. To retain the freshness and nuances of direct colour application, Kandinsky refrained from varnishing his works from 1909 onwards.

Münter also acknowledged the benefits of working communally and, in her diary of 1911, recalled: 'After a short agonising period I have taken a big leap – from copying nature, more

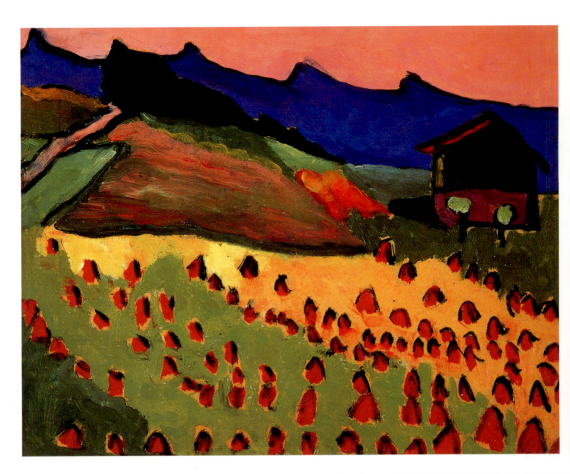

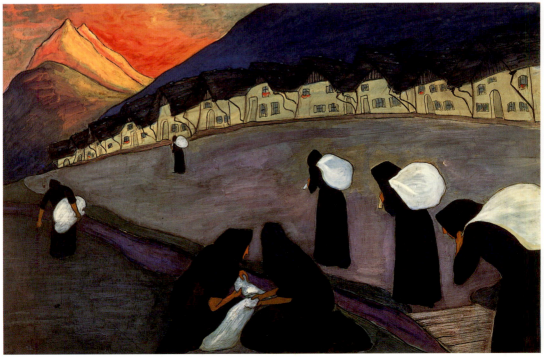

or less impressionistically – to feeling the content, abstracting, drawing out an extract.' Her works abandoned the Impressionist qualities of her Sèvres sojourn to assume the values of Expressionism. With their unusual palette of blue, green, yellow, and pink, with red for emphasis, the diverse surfaces and facture of Münter's Murnau vistas are bound together by a strong sense of composition and contour, as in *Landscape with Hut in the Sunset* 1908 (fig.26). These small-scale oils on board served as an increasing stimulus for technical radicalism as the artist negotiated a path between Jawlensky's Matisse-linked modernism and the inspiration of folk and child art.

According to Münter, it was Jawlensky who first drew her attention to Bavarian and Bohemian glass painting and the technique known as *Hinterglasmalerei* (painting behind glass). A substantial collection was owned by a local brewer in Murnau, Johann Krötz. Münter started her own collection, recreating the votive corners of Bavarian interiors. She copied traditional examples of this genre (images of patron saints or Madonna and Child), both she and Kandinsky learning the technique from Heinrich Rambold, a glass painter still active in Murnau. Notwithstanding the fact that the production of folk art had long been part of a thriving industry – stimulated by the expanding tourist economy in the region – the group cherished the neo-romantic belief in the innocent religiosity and naive originality of folk artists.

The period of Münter's training in Munich, saw the opening, in 1900, of the folk-decorated interiors in the new building of the Bavarian National Museum. Monthly issues of *Volkskunst und Volkskunde*, lavishly illustrated publications of the Society of Folk Art and Folklore, appeared regularly from 1903 onwards. As indicated earlier, cultural critics, such as Julius Langbehn, advocated a rebirth of 'Germanness' through the recovery of the 'spiritual' values of pre-industrialised communities. Thus, the Bavarian interludes of these artists were implicated in a prevailing discourse on modernity and its impact on city and country life.

By the time she resumed painting in 1906, Werefkin revised her understanding of what constituted high art. Undoubtedly, the impact of her second visit to Paris with Jawlensky in 1905, and the viewing of the Salon d'automne, had confirmed her theoretical departure from naturalistic form and colour. Werefkin's thematic departures differed from those of Jawlensky, Kandinsky and Münter. She concerned herself with the social topic of labour, her frequent portrayal of peasantry, for instance, having much in common with the paintings of the school of Pont Aven. However, in other works on the theme of labour, as in the large scale *The Black Women*, 1910 (fig.27), the depiction of processions of darkly clad women, burdened by white bundles, indicates a less than idealised commentary on peasant life in the changing economy of the region.

By this time too she had abandoned earthy tonalities and the medium of oil painting on canvas. Instead, she favoured the use of primary colours and the quicker drying processes of a mixed technique: watercolour, gouache and/or tempera on paper or board. In the preparatory study for *The Black Women* (fig.28), the figures featured so prominently in the final work are incidental and appear as mere flecks in the total orchestration of the vivid colours. Here, Werefkin worked in a more intuitive manner in responding to the scene; however, in the final painting, the stylising process is more accentuated and dramatic use is made of silhouette, spatial distortion and mood-evoking colouration. Evidently, Werefkin was familiar with the work of Edvard Munch, who frequently exhibited in Munich. It is instructive that she looked to the expressive distortions of Munch and not to the primitivising aspects of folk and child art, the inspiration of which was so pivotal to the modernism of Münter, Jawlensky and Kandinsky.

Evidently, the collaboration of these artists was of mutual benefit, each retaining the distinctiveness of their statement, while pursuing similar theoretical and technical objectives. However, the promotion of the cult of the individual in Expressionism, just as much an economic as an ideological issue during this period, was at odds with the idealism of extended communal practice. Just how these conflicts manifested themselves is well exemplified within the broader context of the NKV group in Munich.

The NKV, Kandinsky and Abstraction

On 22 March 1909, the name of the NKV was placed in the Munich city records. The initial idea of an exhibiting society was formulated at one of the salons held at Werefkin's residence in January that year. Its membership would be drawn from the performing, literary and visual arts, testifying to the make-up of the Werefkin social milieu. Apart from Werefkin and Jawlensky, and Kandinsky and Münter, the other founder members were the graphic artist Alfred Kubin, the American Adolf Erbslöh, and Alexander Kanoldt, who came from Karlsruhe. Before the end of 1909 Paul Baum, Karl Hofer, Vladimir Bechtejeff, Erma Bossi, the sculptor Moissey Kogan and the dancer Alexander Sacharoff had joined, and the Frenchmen Pierre Girieud and Henri Le Fauconnier became members in 1910. After a fierce critical reception of the second exhibition of the NKV, Franz Marc wrote a defence of the Association and joined the group in February 1911. By that stage, however, its success was already in question.

As the most experienced, Kandinsky served as president until January 1911, at which point Erbslöh succeeded him. In 1909, through the auspices of the director of the Bavarian National Museums, Hugo von Tschudi, Kandinsky was introduced to the art dealer Heinrich Thannhauser. The commercial climate for contemporary art in Munich recovered marginally in Autumn 1909 when Thannhauser opened his own Modern Gallery, which proved both a beneficial and attractive venue for the annual group exhibitions of the NKV between 1909 and 1911. The following statement by Kandinsky was reproduced in the catalogue for the first exhibition:

Our point of departure is the belief that the artist, apart from those impressions that he receives from the world of external appearances, continually accumulates experiences within his own inner world. We seek artistic forms ... that must be freed from everything incidental, in order powerfully to pronounce only that which is necessary – in short, artistic synthesis.

Far from being a manifesto, this declaration proclaimed the need for artistic diversity, provided that an Impressionist mode of recording the outer world was rejected and a synthetic approach adopted. Concurrently, in his 'Letters from Munich', which were published in the Russian journal *Apollon* between 1909 and 1910, Kandinsky confirmed the NKV's distance both from professional exhibiting organisations and the Secession. Here he denounced Impressionism, nature lyricism and Jugendstil, the three elements that made up 'the soulless "Munich school of painting" ... Naked bodies in the open air, without any attempt at painting. Women lying on the ground with their heels to the spectator ... Geese flapping their wings.' From his viewpoint, the 'provinces of nature' and the 'provinces of art' were independent realms, and the private galleries, such as Thannhauser's, were praised for their boldness in sponsoring the latter.

It was, therefore, a single unity of purpose, the need for exhibiting space, that brought the disparate factions together within the NKV. Thus, in the second exhibition held at Thannhauser's Gallery in September 1910, in addition to those artists already cited, Kandinsky included the Fauvists – Derain, Vlaminck and van Dongen – and Cubist works by Braque and Picasso, and by the Russians David and Vladimir Burliuk. Critics railed against the 'foreignness' of this cosmopolitan gathering, and the decadent and pathological madness of the exhibits. G. J. Wolf commented in *Die Kunst für Alle* (November 1910): 'The beautiful and culturally renowned name of Munich is being used as a roost for an artists' association of mixed Slavic and Latin elements ... There is not one Munich painter amongst them.' Furthermore, he stated that he would have fewer objections if Kandinsky's *Composition 2* were labelled a '"Colour Sketch for a Modern Carpet" ... on a par with "designers"'.

By 1910, Kandinsky was working in three parallel modes, which he called Impressions, Improvisations and Compositions, depending on the degree of reference to the outer world. Clearly, the Compositions were his most intensively researched works, comparable in musical terms to symphonic structures. In the painting *Cossacks*, of early 1911 (fig.29), which is closely related to *Composition 4* (Kunstsammlung Nordrhein Westfalen, Düsseldorf) of the same year, the landscape and figural elements have been abstracted and reduced to ciphers. In order to recognise the motifs, they need to be 'read' in relation to his other works. In the right foreground, three Cossacks with high red hats are portrayed standing before a blue hilltop, surmounted by a fortress. On the upper left, Cossack horsemen with lilac sabres are depicted interlocked in battle above a rainbow bridge. A flock of birds (mere zig-zag lines) links the separate sections.

As Kandinsky would have it, though, the spectator should not respond to this 'hidden' narrative, but to the pictorial elements as an expression of abstract

content: the independence of line from colour, and the saturated accents that cause the eye to move across the purity of the white, primed surface. Interestingly, in negotiating abstraction, Kandinsky used the control over the female body as a metaphor for his encounter with the canvas. In his *Reminiscences* (1913), he wrote about his 'struggle with the canvas' and the action of the 'imperious brush', as the conquest of virginal territory: 'like a European colonist who with axe, spade, saw penetrates the virgin jungle where no human foot has trod, bending it to conform to his will.'

This description of the intuitive creative process locates Kandinsky's practice within the conceptual framework of Expressionist theory. Within this gender-specific rhetoric, the victory of 'spirit' over female 'matter' was viewed in

utopian terms, as the source of the Expressionist artist's higher masculinity. Yet, as mentioned above, in aligning Kandinsky's works with applied art, critics drew attention to their 'lesser' feminine, craft-like associations. It is instructive, therefore, that Marc, in his defence of the second exhibition of the NKV in September 1910, found it necessary to preempt such accusations, by crediting this 'new definition of painting' with the status of high art.

In the preparations for the third exhibition of the NKV in 1911, a controversy arose between the conservative group centred around Erbslöh and Kanoldt and the more radical painters under Kandinsky's leadership. The immediate cause was the committee's ruling that an artist could hang two pictures without submitting them to the jury, as long as their area did not

exceed four square metres (43 square feet). Because of its dimensions, Kandinsky's *Composition 5* (fig.30) had to go before a jury. On its rejection, Kandinsky, Marc, Münter and Kubin resigned from the NKV on 2 December 1911.

The iconography and treatment of this painting indicated a turning point in Kandinsky's *oeuvre*. In his important 'Cologne Lecture' of 1914, he revealed: 'I calmly chose the Resurrection as the theme for *Composition 5*, and the Deluge for the sixth. One needs a certain daring if one is to take on such outworn themes as the starting point for pure painting.' Kandinsky's interpretation of apocalyptic redemption has been attributed to his keen interest in the theories of the German Christian theosophist Rudolf Steiner, whose lecture he had attended in Berlin in 1908. In particular, Steiner focused on the last book of the New Testament, the *Revelation of St John*, as crucial to an understanding of the spiritual crisis in the modern age. Within the flow and flux of the dematerialised surface in *Composition 5*, however, there are only a few motifs that are identifiable – the toppling towers of a hilltop town, riders, and in the upper corners, the streaming hair of apocalyptic angels blowing trumpets. The sound issuing forth from a trumpet, a black whiplash contour derived from a Russian folk-art *lubok* (woodblock), threatens this evocation of a cosmic landscape.

29
Wassily Kandinsky

Cossacks 1910–11

Oil on canvas
94.6 × 130.2
(37 × 50¾)
Tate Gallery

30
Wassily Kandinsky

Composition 5 1911

Oil on canvas
190 × 275
(74¾ × 108¼)
Private Collection

That the debates regarding the direction of contemporary art were intensely concerned with the sponsorship of a national culture, can be gauged from the substance of the treatise *Das neue Bild* (The New Painting), written by the art historian Otto Fischer in 1912, one of the professional members of the NKV. Ostensibly a history of the exhibiting group, in it Fischer stressed the importance of 'objective reality' in attempting to counteract the abstract and mystical principles at work in Kandinsky's paintings and in his treatise *On the Spiritual in Art*, published earlier that year:

> A picture without objects is meaningless. Half object and half soul is sheer delusion. These are the incorrect ways of swindlers and cheats. The confused may well talk of the spiritual: the spirit does not confound, but clarifies.

Fischer's distrust of painting that was 'solely expression' and his predisposition towards the German tradition in the NKV, essentially an internationalist group, is one of the early manifestations of a need to bring order from chaos, to bring modern art in line with bourgeois conservatism. However, this publication caused the withdrawal of Bechtejeff, Jawlensky and Werefkin from the association and, in that no further exhibitions were held, signalled the demise of the group.

The Exhibitions of the Blaue Reiter

Immediately after their resignation from the NKV, Kandinsky and Marc set about organising the first exhibition of the Blaue Reiter, held from 18 December 1911 until 1 January 1912 at Thannhauser's Modern Gallery. In view of the limited time in which they had to arrange this, the name was adopted from their project of the *Blaue Reiter Almanac*, the essays and illustrations of which Marc and Kandinsky had been collating since the summer. Kandinsky's preface to the catalogue explained:

> In this small exhibition, we do not seek to propagate any one precise or special form; rather, we aim to show by means of the variety of forms represented how the inner wishes of the artist are embodied in manifold ways.

The pluralism attested to by Kandinsky is borne out by the exhibits. In total, the exhibition contained forty-three works by fourteen artists, including Kandinsky, Marc, Münter, the Burliuk brothers, Robert Delaunay, Le Fauconnier, Henri Rousseau, August Macke, Heinrich Campendonk, Jean Bloé Niestlé, Albert Bloch, Eugen von Kahler and Arnold Schoenberg.

Kandinsky himself exhibited works that ranged over the various categories and media with which he was currently engaged: the much disputed *Composition 5*, *Improvisation No.22*, the now lost *Impression 'Moscow'*, and three paintings on glass. Marc submitted four paintings that, apart from one landscape, focused on his pantheistic interpretation of the animal in nature. As conveyed in his letters to Macke in 1910, Marc formulated complex theories that invested the primary and secondary colours with psychological and gendered attributes; for instance, blue was associated with the spiritual, male principle, yellow with

earthy, female qualities. The avant-garde was not immune to the patriarchal attitudes of the period in adopting the gendered stereotypes of culture versus nature. In his painting *The Yellow Cow*, 1911 (fig.31), Marc celebrated the nurturing and the earthiness of the domestic animal. He portrayed it arrested in dynamic movement, defying gravity, but organically related to the curves of the landscape.

In view of the anti-naturalistic and reductive language that Marc had adopted, it is not surprising that the younger artist, Paul Klee, a Swiss who had settled in Munich in 1906, asserted in his 'Review of the first Blaue Reiter Exhibition': 'These are primitive beginnings in art, such as one usually finds in ethnographic collections or at home in one's nursery. Do not laugh, reader! Children also have artistic ability . . . Parallel phenomena are provided by works of the mentally diseased.'

31
Franz Marc

The Yellow Cow 1911

Oil on canvas
140.5 × 189.2
(55½ × 74½)
The Solomon R.
Guggenheim Museum,
New York

32
Wassily Kandinsky

Cover of *Der Blaue Reiter* Almanac 1911

Coloured woodcut on cardboard
27.9 × 21 (11 × 8¼)
Los Angeles County
Museum of Art,
purchased with funds
provided by Anna Bing
Arnold, Museum
Associates Acquisition
Fund, and deaccession
fund

Though evidently praising the virtues common to the 'primitives' and the moderns, Klee displayed an entrenched Darwinism in equating the ethnographic with child art and the art of the insane. This syncretic attitude was nowhere better illustrated than in the *Blaue Reiter Almanac*, which was eventually published in May 1912 by the Munich firm R. Piper & Co.

Kandinsky gave a rather superficial account of the title's origins, as arising from a coffee-table discussion with Franz and Maria Marc: 'We both liked blue: Marc – horses, I – riders' ('Der blaue Reiter Rückblick', *Das Kunstblatt*, 1930). However, the colour blue, invested with spiritual connotations by both artists, and the rider motif,

were richly evocative symbols. They signified a range of meanings, from the masculine virtues of charging medieval knights and Christian warrior saints, to the legacies of German Romanticism.

Indeed, in the woodcut cover for the *Almanac* (fig.32), Kandinsky seized on the image of St George, the patron saint of Murnau and Russia, as emblematic of the artist's spiritual mission. In deriving this motif from a Bavarian glass painting, Kandinsky made it evident that his specialist knowledge of ethnography, as evinced in the work *Motley Life*, had been brought into a dialogue with the so-called 'unskilled' vocabulary of folk art. At the same time, his attraction to the rituals of Zyrian culture led to his identification with notions of shamanism. His *Reminiscences* described the artist's talent in similar terms to the shaman's mythical journey as a horseman, from the earthly to the spiritual realm: 'The horse carries the rider quickly and sturdily. The rider,

however, guides the horse. The artist's talent carries him to great heights quickly and sturdily. The artist, however, guides his talent.' Hence, the rider motif, as symptomatic of the generative powers, was intimately connected to the identity of the male artist.

In her *Still Life with St George* of 1911 (fig.33), illustrated in the *Blaue Reiter Almanac* and discussed by Kandinsky in his essay 'On the Question of Form', Münter contrasted the rider motif with the domesticated feminine realm. In this still life, she combined a motley assortment of images: a Madonna statue, small crib figurines from Oberammergau, a ceramic hen, a vase of flowers. On the left-hand side, painted in a hazy aura, the motif of St George escapes the boundaries of the frame of the glass painting. Divorced from their original location or narrative sequences, the votive objects are animated by inconsistent effects of lighting and invested with new mythic associations. Sharing in the

33
Gabriele Münter

Still Life with St George
1911

Oil on board
51.1 × 68 (20⅛ × 26¾)
Städtische Galerie im
Lenbachhaus, Munich

aesthetic of the primitivist ideology of the Blaue Reiter, Münter's recovery of Bavarian folk art transformed the inspiration of these artifacts into an intriguing departure for Expressionist art.

The second exhibition of the Blaue Reiter, entitled *Schwarz Weiss* (Black White), was held from February to April 1912 at the private gallery of Hans Goltz. Devoted exclusively to graphic art, it included works by Emil Nolde and members of the Brücke. As did that community of artists, the Blaue Reiter sought to establish links with Berlin. This was achieved primarily through the agency of the musician, writer and art dealer Herwarth Walden, whose gallery, Sturm, was established in 1912. In this context and in his journal publication *Der Sturm*, Walden was responsible for disseminating notions of Expressionism, the details of which will form the substance of the next section.

MODERNITY AND ITS CONFLICTS: BERLIN

Between the unification of Germany in 1871 and the First World War, Berlin, as capital of the new empire, was subject to immense changes. This modernisation was symptomatic of the economic power that lay behind Prussia's military might. Compared to either Britain or France, Germany experienced industrialisation relatively late. Berlin served as a base not only for national, military and local administration, but also for the manufacturing and industrial sectors, and financial and banking services. Concomitant with political supremacy, the city became the locus of an expanding economy.

Its physiognomy underwent constant and radical metamorphosis, as factories and railway stations rose, cheek by jowl, with other new constructions: from the redbrick city hall in 1875, to the first department store in Berlin, Wertheim's of Leipzigerstraße, which was started in 1896. Designed by the architect Alfred Messel, it was one of the first modern buildings in Berlin to devote itself to the spectacle of consumerism and display. Inevitably, features of progressive modernity, such as the installation of electric lighting, were accompanied by the negative impact of urbanisation. Between 1800 and 1900, the city's population alone had increased from 170,000 to nearly two million, as a consequence of the continuous flow of immigrants, mostly from the rural areas of Eastern Prussia.

These staggering demographic changes gave rise to the spread of the *Mietskaserne* – the five storey tenement blocks, ranged around courtyards, with single accesses to the street. Prevalent particularly in working-class districts to the north of the city, the overcrowded and squalid conditions of these areas

contrasted forcefully with the salubrious environs expanding to the west of the Tiergarten (zoological gardens) – the largely middle-class suburbs of Charlottenburg and Grunewald. The military-bureaucratic capital of a simpler age was transformed into an imperial metropolis or *Weltstadt*, harbouring the tensions and contradictory experiences of modern life. Not surprisingly, in the political context, the principles of the German Social Democratic Party, founded in 1875, gained particular credence in the early twentieth century. Moreover, the discipline of sociology came of age, as social theorists, like Georg Simmel, annotated the impact of high capitalism on urban society.

The lure of the metropolis was not limited to immigrants or merchants

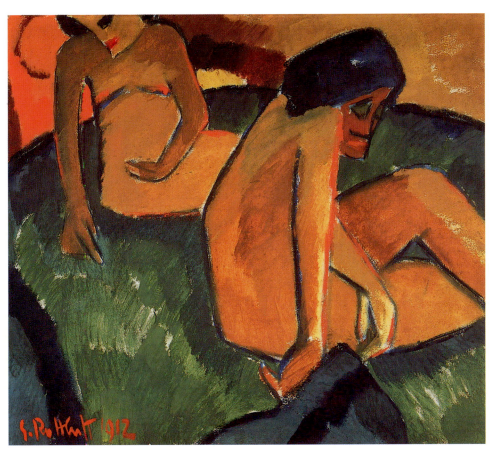

34
Karl Schmidt-Rottluff

Two Women 1912

Oil on canvas
76.5 × 84.5
(30¼ × 33¼)
Tate Gallery

35
Ernst Ludwig Kirchner

Tänzerin (Dancer) 1912

Wood H.134 (52¾)
Private Collection

seeking viable alternatives. Artists, writers and musicians too sought out new and diverse opportunities in a broader environment. In his autobiography, *Ein kleines Ja und ein grosses Nein* (A small yes and a large no), published in 1946, George Grosz recalled his training in the Dresden Academy, but wrote with greater relish about his daily routine while on a stipend at the Academy in pre-war Berlin. He would go outdoors and sketch 'the outskirts of the city, expanding like an octopus … those bizarre city landscapes where trains teamed on overpasses, garbage dumps crowded garden allotments, and concrete mixers were ready for newly laid streets'. Then there was café society, popular entertainment and night life, characterised by Grosz as an 'extraordinarily

interesting merry-go-round!' The well-known Café des Westens on Kurfürstendamm, or the Josty in Potsdamer Platz, served as venues to observe and sketch passers-by and as meeting points for intellectual circles.

Yet, at the same time, Grosz acknowledged the conflicts metropolitan culture held for the modern artist:

> Today art is merchandise that can be sold with clever promotion exactly like soap, towels or brushes, and the artist has become a sort of manufacturer who must produce new goods with ever increasing speed for ever-changing show windows.

In the face of commodification, avant-garde artists needed to construct a new and adaptable identity in order to secure a niche in the market economy of late Imperial Germany. This was true, as well, for members of the Brücke. After participating in the inaugural exhibition of the Neue Secession, they followed Pechstein's example and moved from Dresden to Berlin in October 1911. In November, Kirchner took over Pechstein's studio at 14 Durlacher Straße in Wilmersdorf, where they founded the MUIM-Institute devoted to modern instruction in art. Conceived as a means of generating income, the school offered a curriculum encompassing the fine and applied arts. As their advertisement stated: 'Modern instruction in painting, graphic design, sculpture, rug design, glass and metal work, painting in architectural contexts ... Contemporary life is the point of departure for creation.'

Though the school itself was not a great success, members of the Brücke evidently promoted Expressionism as a means of improving the environment of a modern, industrial society. This principle of *Lebensreform*, that stressed the interaction between art and life, continued to inform their work based on themes derived from their experiences of the city and country. While Kirchner visited the Baltic island of Fehmarn from 1908 onwards, he also undertook excursions to the Moritzburg Lakes with Heckel, Mueller and Pechstein in 1911. Between 1907 and 1912, Schmidt-Rottluff spent the summer months at the Dangast coast on the North Sea. The dunes, grasslands, fishing villages, and harbours served as motifs for the landscape idylls and bather scenes that played a significant role in his *oeuvre*.

In the work *Two Women* (fig.34), painted in 1912, the contemplative women are portrayed seated amidst the undergrowth of the dunes. The primitivised facial features and relief-like, enclosing contours of the figures, point to Schmidt-Rottluff's acquaintance with Cameroon masks and Palau carving. Yet the angularity of the composition and Cézannesque handling of the paint also suggest the impact of Cubist works encountered at the Sturm gallery in Berlin. During 1913, Schmidt-Rottluff painted six further monumental bather canvases in Nidden, on the Baltic Sea, which demonstrated a more intense colouration and a more organic relationship between the figures and landscape.

Whereas the components of Schmidt-Rottluff's atavistic statement are generalised beyond recognition of specific models, Kirchner's representations of the nude retained references to the world of dancers and variety performers he encountered in Berlin. While the gait and proportions of the wooden sculpture *Dancer* (fig.35) are based on African and exotic prototypes, the facial detail and hairstyle evoke those of his Berlin partner, Erna Schilling. In *Dancer*, the largest of his works executed in this medium, Kirchner emphasised the authenticity of the original tree trunk by allowing it to dictate the subtle arabesque and gestures of the figure. *Dancer* is also one of the only examples of his sculpture to be left unpainted, revealing that in it Kirchner exploited the technique of direct carving, allowing the textures and uneven surfaces of the material to disclose traces of his creative process. It is understandable, therefore, why the Brücke's exploration of the three-dimensional medium served as the paradigm of Expressionist sculpture in histories of the movement.

At this time, Kirchner's interpretation of city life, particularly in the depiction of street and crowd scenes, acquired a sense of urgency and intensity. Criticism of the expanding metropolis abounded in the media. The art historian and editor, Karl Scheffler, painted an unflattering image of 'the capital of all ugliness' in his book *Berlin: Ein Stadtschicksal* (Berlin: A City's Destiny), published in 1910. For other commentators, the results of changes in the urban environment – rootlessness, alienation and anonymity – were exciting phenomena. In 1908, in his book *Die Schönheit der großen Stadt* (The Beauty of the Metropolis), the Jugendstil designer and architect, August Endell, celebrated the lack of tradition of Berlin, introducing the concept of the *flâneur*, or voyeur, into German debates on the city. While Endell was conditioned by French Impressionism and the fugitive play of light, Expressionism substituted for this a new mythology of the city.

The formal language of Kirchner's Berlin canvases, jagged and angular, reveals his awareness of the Italian Futurist exhibitions inaugurated by the Sturm gallery in April 1912. However, in the work *Two Women on the Street* (fig.36), painted in 1914, the gaze of the artist as *flâneur* has greater currency than the depiction of either atmospheric changes or the celebration of contemporary life. Derived from rapid sketches made in the Friedrichstraße district of the city, an area which was well known for low-life and prostitution, Kirchner depicted women in the public sphere both as consumers and as part of the spectacle, as saleable objects, garbed in the latest fashionware. The concept of modernity became inseparable from artificiality and the commodification of the female body, transformed by the masquerade of display. As soliciting was officially illegal, prostitutes were forced to recruit clients covertly in streets, cafés, taverns and dance halls, a factor which may have given rise to the circumspect poses of Kirchner's depictions. Clothing, such as the plumed hat and the widow's veil, functioned both as disguise and signifier of the streetwalker.

The erotic ambiguity of these works, the metaphor of Berlin as the whore of Babylon, had its parallel in Expressionist poets' sublimation of the urban experience. Through their acquaintance with Simon Guttmann, art critic of

36
Ernst Ludwig Kirchner
Two Women on the Street 1914

Oil on canvas
120.5 × 91 (47½ × 36)
Kunstsammlung
Nordrhein-Westfalen,
Dusseldorf

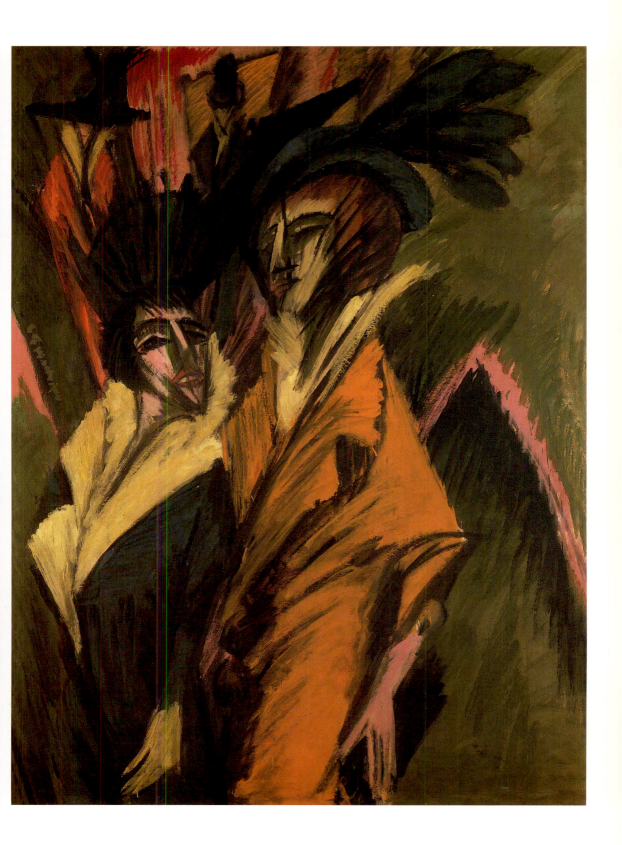

the journal *Der Demokrat*, members of the Brücke made contact with the literary circle known as the Neue Klub. Formed in 1909, the club evolved from a student association founded at the University of Berlin. It featured regular poetry readings, called the Neopathetisches Cabaret, for which Schmidt-Rottluff designed the head-pieces of the last two programmes, performed in late 1911 and early 1912. In particular, Georg Heym's poem *Umbra vitae*, published in a posthumous collection in July 1912, had a major impact on Kirchner. This resulted in the publication of forty-seven woodcut illustrations by him, in a reprint of Heym's poem issued by the publisher Kurt Wolff in 1924.

The versatility of the artist as craftsman, painter, sculptor and illustrator was extended to encompass literary and theoretical endeavours. In 1913, Kirchner wrote his *Chronik KG Brücke* in an attempt to formulate a defined aesthetic programme. This sealed the fate of the group which had already started to disintegrate. Pechstein was expelled in late 1912, as a result of his willingness to exhibit in the Berlin Secession exhibition. Schmidt-Rottluff and Heckel, dedicated to the community's initial aspirations of intuitive experimentation, disputed Kirchner's version of the history of the group. Notwithstanding the dissolution of the Brücke, the principle of the *Doppelbegabung*, or double talent, was a central feature of Expressionist identity, as artists adapted to the sponsorship and networking of metropolitan existence.

Of great importance to the promotion of Expressionism was the role played by private commercial enterprise. The dealer Wolfgang Gurlitt, who inherited his father's Galerie Fritz Gurlitt in Berlin, launched a major exhibition of Brücke painting, sculpture and graphics in April 1912. Like Gurlitt, Paul Cassirer and Herwarth Walden exploited a burgeoning publishing industry, improved communications and the growth of an international art market for their particular style of dealership. Just how Expressionism developed in relation to such impresarios and to the activities of distinctive urban literary circles will be explored below.

EXPRESSIONISM AND DEALERSHIP: HERWARTH WALDEN AND *DER STURM*

Born in Berlin and trained as a musician, Herwarth Walden was pivotal to the reputation of the city as a centre of avant-gardism. His name, a pseudonym for George Lewin, was suggested by his first wife, the poet Elsa Lasker-Schüler. She was also responsible for providing the vivid title of his periodical *Der Sturm* (storm, struggle), which was conceived as a counter-statement to bourgeois complacency. Launched in 1910, *Der Sturm* remained in print until 1932. While its frequency of publication, content and format varied over this period, the journal consistently featured articles on art theory and criticism, poetry, literature and, as it developed, the reproduction of contemporary graphics and drawings.

37
Oskar Kokoschka

Mörder, Hoffnung der Frauen (Murderer, Hope of Women) 1910

Drawing for the cover of *Der Sturm*, no.20, 14 July 1910
Los Angeles County Museum of Art, Gift of Robert Gore Rifkind

38
Oskar Kokoschka

Portrait of Herwarth Walden 1910

Oil on canvas
100 × 69.3
(39½ × 27¼)
Staadtsgalerie Stuttgart

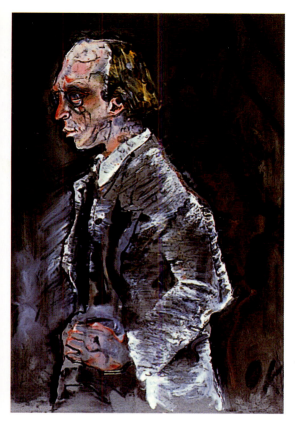

Walden soon affiliated the periodical with a publishing house and, in 1912, inaugurated the Sturm art gallery in the fashionable Tiergarten district. Evening readings were arranged and, from 1918, plays were staged. One of the first artists to benefit from this interdisciplinary enterprise was the Viennese Oskar Kokoschka. In 1907, he trained in the applied arts at the *Wiener Werkstätten* (Vienna Workshops) but, in fact, it was the performance of his first one act play, *Mörder, Hoffnung der Frauen* (Murderer, Hope of Women), at the Wiener Kunstschau in 1909, that brought him initial recognition. In July 1910, the text of the play, accompanied by a drawing, was published on the title page of the twentieth issue of Walden's *Der Sturm*.

The cover page (fig.37) acquired a distinctive appearance, a poster-like combination of title headings, script and images. In reproduction, Kokoschka's pen and ink drawing retained its urgency of line in conveying the climax of the misogynist drama – the symbol of matriarchy succumbing to male aggression. Though the action was set in Greek antiquity, the theme itself was particularly modern in focusing on the battle of the sexes. Typically Expressionist, the style of drawing is anti-mimetic, the striations alluding to tribal practices of decorating and incising the body. The text of the drama was similarly abstracted, involving a high degree of expressive intensification in conveying the dark mood.

Prior to his participation in the opening group exhibition of the Sturm gallery in March 1912, Kokoschka functioned as editor responsible for the publication of *Der Sturm* in Austria from October 1910 until October 1911. To advertise the periodical, he produced posters that became collectors' pieces in their own right, portraying himself in the guise of an ascetic martyr. By 1912, the object of this promotional exercise was realised when Paul Cassirer, largely known for his dealings in modern French and Secessionist art, brought Kokoschka his first real income in the form of a contract. Moreover, though largely self-trained as a painter, Kokoschka became a much sought after portraitist. He overlaid his canvases with a prismatic net of coloured lines and patches of colour, while retaining a ghostly, insightful appearance of his sitters. His three-quarter length, profile *Portrait of Herwarth Walden* (fig.38), commissioned in 1910, testified to the dealer's influential status as both collector and patron.

During the pre-war period, the Sturm gallery also displayed the works of other artists deemed Expressionist – the members of Brücke, Der Blaue Reiter and Ludwig Meidner, from the group known as Die Pathetiker. In particular,

through Walden's promotion in *Der Sturm*, Kandinsky came to be regarded as one of the movement's chief exponents in Germany. His publications in 1912 were pivotal to Walden's mystical definition of the Expressionist process: 'The painter paints whatever he sees with his innermost senses, the expression of his being . . . his inner apparitions.' So Walden wrote in his foreword to the catalogue of the Erster Deutscher Herbstsalon (First German Autumn Salon), held in Berlin in 1913, in which he equally championed other areas of the European avant-garde art – Futurism, Cubism, Orphism. This was a significant international event involving the display of works from fourteen countries.

In his various catalogues and editorials, Walden used the term Expressionism to embrace what he generally understood to constitute early modernism. In a Nietzschean way, he perceived creativity, originality and authenticity as a necessary antidote to the conventionalism of Wilhelmine culture. Typically cosmopolitan, amidst much criticism, Walden pursued the French avant-garde at the height of pre-war national paranoia. Furthermore, his promotional skills were not limited to marketing Expressionism in Germany. In order to ensure a wider audience, travelling exhibitions were sent to Scandinavia, Finland and Tokyo before, and even after, the outbreak of the First World War.

NUANCES IN THE EXPRESSIONIST AVANT-GARDE, PRINT COMMUNITIES AND MODERNITY

While the painter, graphic artist and writer Ludwig Meidner made his debut at the Sturm gallery, his attempts to align his Jewish heritage with modern-day secularism and socialism differentiated his contribution from Walden's less politicised brand of Expressionism. Meidner pursued an academic training at the Royal School of Art in Breslau in 1903, moving to Berlin in 1905, and broadening his experience of city life in Paris between 1905 and 1907. Nonetheless, his correspondence at the time revealed a preference for Berlin, the 'struggling, earnest burgeoning city . . . the world's intellectual and moral capital'. Meidner's return to the capital for a compulsory military examination coincided with a renewed interest in themes of modernity. His paintings depicted the rapid transformations that overtook the urban landscape, in broadly applied brushstrokes that retained a link with *plein-airism*.

By 1911, Meidner made contact with avant-garde literary groups that frequented the Café des Westens. In emulation of the Neopathetic Cabaret that attracted well-known Expressionist poets, such as Georg Heym and Jakob van Hoddis, Meidner adopted the title *Die Pathetiker* (The Pathetic Ones) for his major group exhibition held in November 1912 at the Sturm gallery. Along with the artists Richard Janthur and Jakob Steinhardt, he committed himself to the notion of 'pathos', a vitalist and Dionysian concept adapted from the writings of Nietzsche. The city landscape was invested with elements of the primal and the cosmic, as he responded to the theoretical and formal inspiration of the Italian Futurists and Robert Delaunay, featured in exhibitions at the Sturm Gallery in Spring 1912.

In his self-portrait *I and the City* (see Eliel, fig.72), painted in 1913, Meidner's

39
Ludwig Meidner
Apocalyptic Landscape
1913

Oil on canvas
67.3 × 80 (25 × 31½)
The Marvin and Janet Fishman Collection, Milwaukee

image confronting the viewer has frequently been interpreted as the epitome of Expressionist urban anxiety. However, a more ambiguous reading can be suggested. Meidner activated the local colour and impasto surface of the streets with scurrying pedestrians and angular lines of force, surmounting the composition with a hovering balloon and skyscape. Rather than portraying alienation in the metropolis, the artist parallelled his creative powers with the chaos, dynamism and tumult of contemporary life, a view confirmed in his theoretical text 'Directions for Painting the Big City', written for the periodical *Kunst und Künstler* in 1914.

The tendency to regard all Meidner's urban compositions between the years 1912 and 1916 as apocalyptic, as revelatory of the destruction of the First World War, is also misleading. Indeed, of the fifteen paintings featured at the Sturm gallery exhibition in November 1912, only one example was labelled as such in the catalogue. Yet many of his pre-war works (see fig.39) depict cosmic destruction, tottering buildings and fleeing people, evoking the verses of Heym's *Umbra vitae* or van Hoddis' *Weltende* (End of the World, 1911). Meidner's

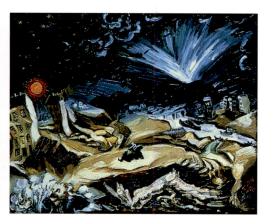

oeuvre, like that of many of his contemporaries in the early twentieth century, was generated from a conflict between his utopian assumptions and a modernising world, which was perceived as fallen, chaotic and compromised.

Within the first few months of the war, Meidner voiced his protest in the graphic cycle reproduced from his drawings entitled *Krieg* (War), a portfolio of eight lithographs, that focused on the psychological and physical devastation of modern warfare. On a private level, the content displayed the artist's intense feelings of loss after his closest friend, the poet Ernst Wilhelm Lotz, was killed on the front in September 1914. Publicly, however, it revealed his political affinities and links with radical left-wing circles and, in particular, with the journal *Die Aktion*, edited by Franz Pfemfert, to which Meidner contributed many anti-war images.

As is suggested by the title, *Die Aktion*, the preference for a more engaged Expressionism was expounded in this Berlin-based journal, which was founded in 1912. Meidner's participation in the group exhibition of Die Pathetiker was also reviewed in its pages. In November 1912, the critic and writer Kurt Hiller, president of the Neue Klub, wrote the following:

> Due to an absence of snob-like determination to obfuscate ... [the painter] Meidner happily differentiates himself from those of the Russo-Munich artists à la Kandinsky, *who have compromised the entire revolution* (and who are therefore well treated by the bourgeois press), whose impotent and not even decorative absurdities are surpassed only by the grandiosity of their swindler's courage.

By virtue of their concrete, and yet anarchic, evocation of modern dilemmas, Meidner's paintings were considered to be more easily legible to a

wide audience. However, those artists of the 'Russo-Munich', Blaue Reiter group, were considered to be elitist and ambivalent, their aesthetic preoccupations lacking any sense of the contemporary world. No doubt Hiller would have favoured the patriotic gesture of the Berlin factory worker in Meidner's painting, *Revolution (Battle at the Barricades)* (Nationalgalerie, Berlin), painted in 1912. That in his diatribe, Hiller was not immune to promoting a form of national cultural policy, is evidenced by the sub-text of the quoted passage: a manliness, which had little time for the 'impotent' artistic production of the Bavarian-based Expressionists.

The discourse of ethical and aesthetic revolution outlined above needs to be viewed against a backdrop of what constituted *serious* art. In another publication dedicated to topicality and cultural intervention, Paul Cassirer's

and Julius Meier-Graefe's journal *Pan*, a heated exchange was entered into by Max Beckmann, then active in the Berlin Secession, and Franz Marc in 1912. In a critique of Marc's earlier article on 'The New Art', Beckmann's 'Thoughts on Modern and non-Modern Art' championed van Gogh, Géricault and Goya, rejecting as 'feeble' and dated the resort to old, primitive styles exemplified by Gauguin. Such views possibly encouraged Beckmann to revive the historical genre by portraying contemporary events, such as *The Sinking of the Titanic*, painted in 1912.

Though still Munich-based, Marc increasingly engaged with literary circles and exhibition organisation in Berlin. His staunchest patron, the industrialist Bernhard Koehler, resided there, having provided financial backing for Herwarth Walden's First German Autumn Salon. The major role played by Marc in the selection and hanging of paintings for this international exhibition

inspired him to be more topical, a task of great difficulty if one recalls his
commitment to an 'animalisation of art'. Of the seven paintings Marc
produced in the Spring of 1913, in preparation for submission to the Autumn
Salon, *The Wolves (Balkan War)* dealt most directly with the contemporary
political ambience. The Balkan powers had declared war on Turkey in
October 1912 and, despite the first Treaty of London having ensued, war broke
out again in May 1913. In Marc's painting, the encoded message was conveyed
by the mobilisation and advance of the predators along the horizontal format
of the canvas.

That *Destinies of the Animals* (fig.40), completed in May 1913, was intended to
be the magnum opus of the group of paintings can be deduced from its scale.
Similarly Kandinsky, Marc's colleague from the Blaue Reiter group, submitted
his *Composition 6 (Deluge)*, a monumental painting which exploited the
abstracted ciphers and organic rhythms derived from his apocalyptic themes. In
his painting, Marc showed an affinity for Futurist opposing force-lines and a
concern for the transparency of vivid colour planes, inspired by Delaunay's
Orphic Cubism. So enthused were Marc and August Macke by Delaunay's
works, that they visited his studio in Paris in October 1912. Marc obtained a
copy of Delaunay's manuscript 'On Light', which Paul Klee translated into

German and published in *Der Sturm* in 1913. Macke explored most fully the implications of Delaunay's theories in his depictions of shopping arcades. In these scenes, the planes of the picture evince the reflected coloured light of the glass windows, separating the women shoppers from the objects on display.

Unfortunately, the full impact of the colouration in *Destinies of the Animals* cannot be appreciated, due to the fact that the canvas was partially consumed by fire while in storage, seven months after Marc's death on the front. In 1917, the task of restoration was undertaken by Klee and Maria Marc who, in accordance with the artist's preparatory sketch, resuscitated the linear structure of the destroyed area without attempting to duplicate the transparency of the colours on the left. Despite this damage and the fragmentation of form, there is an observable narrative structure.

Marc based the composition loosely on Gustave Flaubert's *The Legend of St Julian Hospitalle*, a text which dwelt on the medieval saint's ruthless slaughter of animals. The human agent of destruction was omitted, however, as Marc focused on the central blue doe, portrayed raising its head to sound the alarm for the strange community of animals. Marc's inscription on the rear of the canvas, 'And all existence is flaming suffering', adapted from the Hindu Vedas, can be read quite literally. He depicted angular, flame-like red rays, penetrating nature and animal, and eliciting, in one instance, dripping blood from the tree in the upper left centre. The animals, which Marc had seen earlier as bearing the promise of instinctual renewal, were now considered beasts of calamity, a pessimistic recognition that man acts as both instigator and joint victim of this suffering. Such connotations were akin to New Testament interpretations of the Sacrifice of the Innocents.

The outbreak of the First World War effectively disrupted the broader, European inferences of the development of Expressionism. Klee's jewel-like landscapes, as in the watercolour *Red and White Domes* (fig.41), produced while visiting Tunisia in North Africa with Macke and Louis Moillet in 1914, demonstrate how significant the interaction with French avant-gardism was to the Sturm circle of artists. Macke's painting, *The Farewell* (1914, Ludwig Museum, Cologne), departed from his arcade scenes that portrayed fashionable women and children at shop windows. The mood of the work is sombre and takes on muted tonalities, as Macke represented bowed figures and family groups seeing off volunteers. Factions within the Expressionist avant-garde were disunited, as the historical events unfolded. Even within the Blaue Reiter community, tensions emerged in early 1914, as Kandinsky recruited a new editor, the Serbian student Dimitrije Mitrinovic, with a view to the publication of a second Blaue Reiter Almanac. This project didn't come to fruition since, the moment Germany declared war on Russia on 1 August 1914, all Russian citizens in Germany were declared aliens. Kandinsky and Münter had to leave Munich for Switzerland in haste. Nationalist fervour within Expressionist quarters, though endorsing the German identity of the movement, was short-lived, as the technological nightmare of the Great War intensified political divisions.

WAR, REVOLUTION AND COUNTER REVOLUTION

The sham of European propriety is no longer tolerable. Better blood than eternal deception; the war is just as much atonement as voluntary sacrifice to which Europe subjected itself in order to 'come clean' with itself.

So Marc wrote to his wife Maria from the front on 6 April 1915. Like many of his contemporaries, Marc eagerly volunteered just five days after the declaration of the First World War. Misinterpreting Nietzsche's metaphoric search for the destruction of the civilised self and the renewal of the individual in the full splendour of innocence, many intellectuals embraced the fantasy of war as an opportunity for catharsis. Macke, however, who was sent with the ninth Rhineland infantry regiment to France, had turned against the war by the time he reached the front line. He wrote to his wife Elisabeth on 11 September 1914: 'The people in Germany, drunk with ideas of victory, don't suspect how terrible war is.' His death on 12 October that year was devastating news for his family and colleagues.

Interestingly, Marc's *Sketches from the Field*, a series of thirty-six drawings, did not portray the realities of warfare but continued his pre-war fascination for the cosmic unity of animal and nature. The dynamic and rhythmic abstractions are composed in delicate tones with the cowering shapes of animals harmoniously integrated. Marc's untimely death in action near Verdun at the age of thirty-six, on 4 March 1916, ironically canonised his contribution and alerted opinion to the tragic consequences of war, as his widow dedicated herself to memorialising his legacy.

At the outset, even in political circles, differences were put aside as the Social Democratic Party supported the Imperial government by approving the first war credit loans. Leading exponents of modernism went public about their patriotism, using graphic media as a vehicle to promote national ideology. Between 1914 and 1916, the dealer Paul Cassirer published the weekly journal *Kriegszeit* (War Time), which aimed to circulate modern artists' interpretations of war to a broad audience. In the issue of 16 December 1914, the sculptor, graphic artist and playwright, Ernst Barlach, submitted the lithograph *The Holy War*. This depicted a draped, foreshortened, advancing figure, bearing a sword, an image that invested the battle with religious overtones. This study was derived from his sculpture, *The Avenger* (fig.42), wood and plaster versions of which Barlach was working on in his studio in Gustrow. In 1920, bronze casts were made after the plaster sculpture under the auspices of the Galerie Flechtheim.

Though the figure captures intensity of movement and has a vigorous, streamlined silhouette, the facial expression suggests a more defensive attitude. It is unadorned and monumental, the planes and curves of the bronze surfaces echoing the textures and roughness of Barlach's plaster model. In a letter to the publisher Reinhard Piper (31 December 1911), written after reading a copy of Kandinsky's *On the Spiritual in Art*, Barlach rejected abstraction and stated his position: 'My native tongue happens to be the human form or the milieu, the object through and within which the human being lives, suffers, rejoices, feels and thinks. I can't get beyond that ... It is precisely the touch of vulgarity, the universally human, the primitive sense of race, that are great and eternal.'

As with other artists, Barlach's moral support of the military effort waned. With the war in the west having reached an impasse in 1916, Cassirer, while temporarily demobilised in Berlin, suspended publication of *Kriegszeit*. To reflect the cultural milieu's growing alarm, he replaced it with a new periodical, entitled *Bildermann* (The Man Showing Pictures). This was published twice-monthly and featured contemporary graphics, poetry and short stories. Barlach's contribution to the 15 September 1916 issue satirised the pointless loss of life caused by the war. His lithograph, *From a Modern Dance of Death*, portrayed an ominous giant figure, standing over a mound of skeletons, wielding a sledge-hammer.

Similarly, the other major Expressionist sculptor recognised before the war, Wilhelm Lehmbruck, invested the human figure with the tragedy of the conflict. In his sculpture, Lehmbruck elongated and etherealised the body, drawing on Symbolist sources such as the works of Rodin and the Belgian Georg Minne. Much praise was lavished on Lehmbruck's ability to infuse the sculpture with an architectonic composure

and an affirmative Gothic, spiritual dimension. Yet his over life-size figure, *The Fallen Man* (fig.43), produced between 1915 and 1916, distances itself from his pre-war work. He made use of the attenuated, arched frame of the body, poised on elbows and knees, as a vehicle for conveying the impact of emotional and physical despair. The subject matter was one that matched Lehmbruck's bitter experiences when he served briefly in the medical corps on the front during 1915. At the height of his career in 1919, at the age of thirty-eight, he committed suicide in Berlin.

The turn of the tide in the war after 1916, when Germany was no longer on the offensive, signalled the futility of prolonged militarism. Whether on the battle or home front, many artists became psychic casualties of the war experience. Though the events initially disrupted channels of support and display, they in no way curtailed the setting up of Expressionist reviews and journals. Surprising as it may seem, the art market too staged a remarkable recovery. Before considering the reasons for this and why the topic of the war continued to fuel cultural debates well into the Weimar period, it is instructive to consider general developments in Expressionism during the war.

TRENDS IN WARTIME EXPRESSIONISM: FROM MODERNITY DEFILED TO APOTHEOSIS

Though George Grosz enlisted with a Royal Prussian infantry guard regiment in November 1914, he did not see active service. After spending time in a military hospital, he was considered unfit for service in May 1915. His pacifist sentiments were confirmed due to his association with the literary and artistic circle in Berlin that frequented the studio of Ludwig Meidner, which included Max Hermann-Neiße, Rene Schickele, Raoul Haussmann, Conrad Felixmüller, Wieland Herzfelde and Lehmbruck. His pre-war themes from metropolitan life – proletarian motifs, murder scenes, erotic fantasies – were invested with a new violence and pessimism. They lost their *fin de siècle* overtones as he engaged in Expressionist distortion, dramatic changes in scale and heightened colouration in interpreting the cityscape.

These features are evident in the canvas, *Suicide* (fig.44), painted in 1916,

42
Ernst Barlach
The Avenger 1914,
later cast
Bronze
43.8 × 57.8 × 20.3
(17¼ × 22¾ × 8)
Tate Gallery

43
Wilhelm Lehmbruck
The Fallen Man
1915–16
Bronze
72 × 239 × 83
(28¼ × 88 × 32¾)
Staatliche Museen zu
Berlin, Preubißcher
Kulturbesitz
Nationalgalerie

where the square of an urban red light district serves as an arena in which the futility of existence is staged. A suicide is portrayed hanging from a lampost and, sprawled in the foreground, is the figure of a possible victim of murder. Their lifeless corpses contrast with the lurid red colour that dominates the surface, illuminating both dogs and an apparent murderer or robber on the prowl. The painting also depicts a cheap domestic interior that displays the object of unfulfilled desires – the partially clad prostitute – framed by a window. In this painting, the female body does not constitute the locus of violence and dismemberment, as in Grosz's *John, the Woman Slayer* (1918, Hamburg Kunsthalle) and in his various representations of *Lustmord* (crimes of passion). Nonetheless, the equation of women and modernity, as a threat to masculinity, is a pervasive theme.

After his final discharge from service in April 1917, Grosz became involved with the Malik Verlag, a publishing house which was established on an anti-war

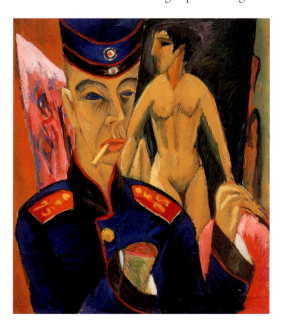

platform in 1916. Under the guidance of its editor Wieland Herzfelde, it channelled its radicalism into support for the German Communist Party in early 1919. In 1917, the Malik Verlag issued Grosz's print portfolio, *Kleine Grosz Mappe*, a series of twenty transfer lithographs. Their focus on scenes of rape, murder and insanity in the city drastically questioned the prevailing order, substituting madness and anarchy in its place. However, there was nothing insane about Grosz's fine line drawings that caricatured and satirised social types, and that drew on child art and Futurist interpenetration of lines, for their forceful impact. In 1918, Grosz became associated with Dada, which began in Zurich in 1916 and spread to Berlin and other cities in Germany. The Dada artists became vehemently critical of their Expressionist heritage.

Military service equally imposed conflicts on Kirchner who was already at odds with the bourgeois conventions of Wilhelmine society. His psychological state was apparently unstable even before he was recruited as an 'unfreiwillig Freiwilliger' (unwilling volunteer) in 1915. The year that he spent training in the Field Artillery in Halle was interrupted by his return to Berlin to recover from severe nervous exhaustion and a lung infection. This condition eventually led to his release from the army to recuperate in a psychiatric sanatorium. During 1915, Kirchner produced sketches that documented the routine of the regiment, for example, the care of their horses. Of all his works at this time, however, the *Self-Portrait as a Soldier* (fig.45) has attracted most comment.

44
Georg Grosz

Suicide 1916

Oil on canvas
100 × 77.5
(39½ × 30½)
Tate Gallery

45
Ernst Ludwig Kirchner
Self Portrait as a Soldier 1915

Oil on canvas
69.2 × 61 (27¼ × 24)
Allen Memorial Art Museum, Oberlin College, Ohio; Charles F. Olney Fund, 1950

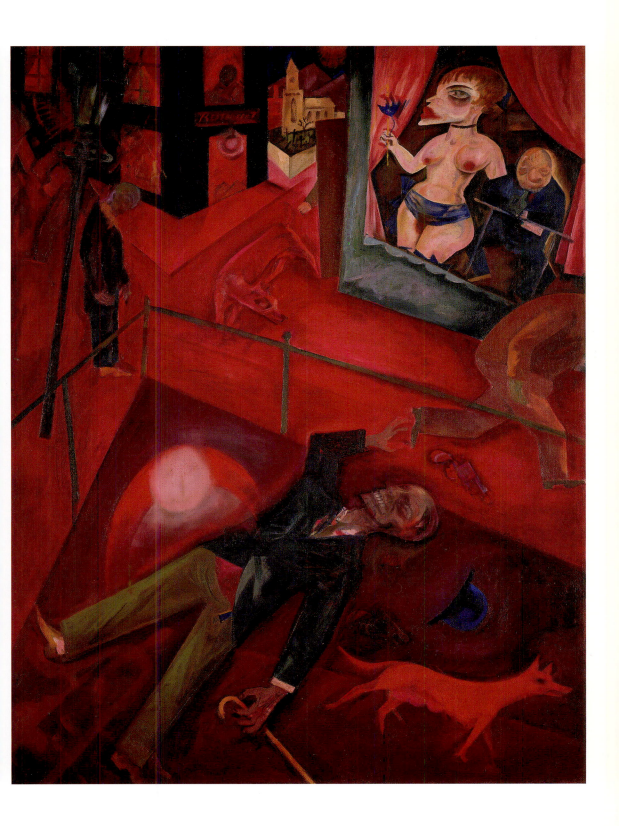

Kirchner portrayed himself dressed in the navy and red uniform of the Mansfield artillery regiment. A cigarette is shown dangling from the edge of his mouth, as his emaciated face confronts the viewer with blank eyes. While his left hand holds a palette, the amputated stump of his right hand is held up for the viewer's attention. However, unlike Beckmann or Otto Dix, Kirchner was neither involved in attending the wounded nor in military action, and the mutilated image has to be interpreted as a more complex metaphor. Behind the artist, a painting of a nude model is depicted resting against an easel, amidst other canvases stacked in the studio interior. The self-portrait powerfully raises the issue of male artistic and sexual identity within the context of Kirchner's ambivalent role as a soldier.

In 1917, the founding of the journal *Das Kunstblatt* (The Art Newspaper), by the influential art critic Paul Westheim, highlighted the growth of public interest in modern art. In the June issue Gustav Hartlaub, a curator of the Mannheim Kunsthalle, wrote a lengthy article, 'Art and the New Gnosticism',

in which he detected evidence of an increasing spiritual element in Expressionism. He felt that the growth of this new and expanded consciousness was accelerated by the events of the war. At the root of his critique was a fervent rejection of scientific and rational modernity, which was seen as a tool of repression. The resort to primitivism, even Grosz's reference to children's drawings, was viewed as a formal necessity to achieve a transcendent statement. Hartlaub set about organising an exhibition, entitled *New Religious Art*, which opened in Mannheim in January 1918, and included the works of many Expressionists.

In Hamburg, the art historian and critic, Dr Rosa Schapire, continued her promotion of the other former Brücke member, Schmidt-Rottluff. Her reviews echoed Hartlaub's findings in relating the artist's work to the same trends. Furthermore, she attributed his preoccupation with religious imagery and mysticism, particularly in his large, planar woodcuts, to the impact of the war:

> The majority of these religious woodcuts ... originated in Russia during the war. Nothing of the agony the artist went through penetrated into the realm of the spirit. As a creator, a builder of new values, he freed himself from all inhibitions and suffering ('Karl Schmidt-Rottluffs religiöse Holzschnitte', *Die Rote Erde*, 1919)

Carved during 1918, these woodcuts were published in portfolio form (*Neun Holzschnitte*) by the Leipzig publisher Kurt Wolff in December of that year. In focusing on the life of Christ as a parable of redemption, the publication was suitably timed to spread a message of hope and renewal at a time of great turmoil.

46
The furniture and interior of Dr Rosa Schapire's apartment in Hamburg, designed by Karl Schmidt-Rottluff. Hanging on the wall is his 1915 painting *Woman with a Bag*

47
Karl Schmidt-Rottluff

Portrait of Dr Rosa Schapire 1919

Oil on canvas
100.6 × 87.3
(39½ × 34½)
Tate Gallery

As far as her private patronage during the war was concerned, in 1915 Schapire purchased the painting *Woman with a Bag* (Tate Gallery, London) directly from Schmidt-Rottluff's studio in Berlin, just weeks before he had to do his military duty as a censor on the Russian front. She assembled an almost complete collection of his prints, enabling her to publish a *catalogue raisonné* in 1924. He was also commissioned to design the furniture and decor of her apartment, a photograph of which demonstrates how the fine and applied art were integrated within the living-room interior (fig.46). Schmidt-Rottluff's *Portrait of Dr Rosa Schapire* (fig.47), painted just after the war, acknowledges these different aspects of her benevolence and professional career. Set in her apartment against the backdrop of one of his works, the sitter is portrayed with an open book on her knees, evidence of the woman's intellectual pursuits.

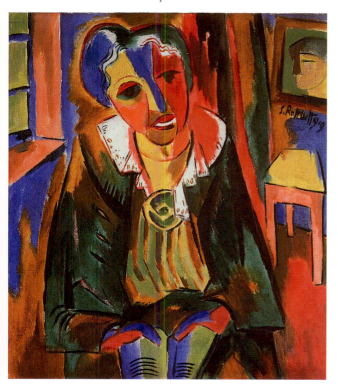

It seems uncanny that art dealing and the expansion of private collections continued unabated during the First World War. As the art historian Joan Weinstein has observed, the ascendance of Expressionism was the result not only of an ideological convergence between Expressionist art and a war-weary bourgeois public, but also the economic conditions of the time. The growth of the war industry during 1915 had steadily boosted the money supply and one of the consequences of this increased purchasing power was an investment in art works, a situation that reached boom proportions by 1917. Tax exemptions on the work of living artists also benefited the Expressionists who drew advantage from this situation.

The regenerative and utopian aims of Expressionism were spurred by the events surrounding the November Revolution. On 9 November 1918, workers and soldiers entered the streets of Berlin and took possession of public buildings. The republic was declared on the same day by the leader of the Social Democratic Party, Philip Scheidemann. This was done in order to forestall more radical left-wingers, namely the Spartacist Union (founded in 1915). Wilhelm II fled to Holland and announced his abdication three weeks later. Expressionists, now defined by their anti-war sentiments, emulated the activities of the soldiers and workers in issuing proclamations and in setting up their own councils modelled after Russian soviets. Though widespread in regional and major centres, the movement was given an initial cohesiveness by the goal of promoting the socialist reconstruction of society and the arts.

EXPRESSIONISM AND POLITICS: UTOPIANISM, PROLETARIAN CULTURE AND THE STATE

Among the organisations set up by artists in Berlin in the immediate aftermath of the Revolution of November 1918, the Arbeitsrat für Kunst (Working Council for Art) and the Novembergruppe (November Group), were the most influential. In December 1918, the Novembergruppe was formed by the artists César Klein, Moris Melzer, Pechstein, Heinrich Richter-Berlin and George Tappert. It called on all Expressionists, Futurists and Cubists to unite, but also attracted Dadaists and was open to the affiliation of groups from regional centres, such as the Dresden Secession Group 1919. At the outset, the utopian aims and rhetoric of the Novembergruppe were indistinguishable from those of the Arbeitsrat and their membership overlapped. However, the agenda of the Arbeitsrat was driven by architects and was more radical in attempting to maintain its revolutionary credentials.

In December 1918, the Arbeitsrat published 'A New Artistic Programme', in architectural journals as well as in two socialist papers, which declared:

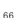

> Art should no longer be the pleasure of a few, but the happiness and life of the masses. The aim is the union of the arts under the wings of a great architecture.
> Henceforth, the artist alone, as the one who gives form to the perceptions of the people, is responsible for the visible raiment of the new state.

The signatories included the foremost modern architects, painters, sculptors, critics and art historians. Among their ranks, Heckel, Meidner, Pechstein and Schmidt-Rottluff were already well known as Expressionists.

The wording of the programme, however, was associated with a group of Expressionist architects. One of these, Bruno Taut, led the council until Walter Gropius superseded him in February 1919. When Gropius became the founding director of the Bauhaus in April, the art historian and critic Adolph Behne assumed leadership. The idea that architecture had a key role to play in the creation of a new society was in fact formulated before and during the First World War, notably by Taut.

The inspiration of Kandinsky was acknowledged in Taut's article 'Eine Notwendigkeit' (A Necessity), published in the journal *Der Sturm* in February 1914. According to Taut, though, it was architecture, as the most directly social of all the arts, that 'must serve as the frame and content all at once'. In its aim to fuse the spiritual and the functional into an expressive total work of art, this text is considered the earliest manifesto to advocate Expressionism in architecture. Moreover, Taut's idea of the Gothic cathedral as the paradigm of the unity of the arts, religious and communal life, became a feature of Expressionist architectural theory.

Both Taut and Gropius were active members of the Deutsche Werkbund, a

trade association established in 1907 that was devoted to reforming design in industry. Taut's *Glass Pavilion*, installed at the Werkbund exhibition held in Cologne in 1914, was dedicated to the Expressionist poet and novelist Paul Scheerbart, whose text *Glasarchitektur* (Glass Architecture) was published in 1914. Like Taut, who stressed the need for technological advance by the use of the modern materials concrete, glass and steel, Scheerbart proposed that the illuminatory power of coloured glass could transform psychological awareness: 'Glass architecture makes homes into cathedrals.' Modernity, it seems, was always tempered by references to the traditions of German Romanticism and to concepts of the sublime, in the passion displayed for the mystical qualities of crystals and coloured light.

On a theoretical level, Taut gave shape to his utopian ideals in illustrated texts, written towards the end of the war, and published in 1919. In the context of war disillusionment, his statements in *Alpine Architektur* reveal his pacifist and socialist stance in appealing to the people of Europe, 'Preach be peaceful! Preach the social idea: "You are all brothers"'. His drawings transform the landscape into a vehicle for communal and modern living. The crystalline peaks of mountains, hewn and smoothed, serve as temples for devotion (the crystal house) or as plateaus for airfields. The emphasis placed on this blueprint activity points to the importance of creative speculation to Expressionist architecture. Taut was so committed to this principle that he established the Gläserne Kette (The Glass Chain) in December 1920, a type of masonic group whose members exchanged ideas on architecture in the form of letters and drawings.

One of the few architects who were able to realise their projects in the immediate post-war period was Erich Mendelsohn. His adventurous sketches for a proposed observatory outside Potsdam, commissioned by Albert Einstein in 1917, were vigorous explorations of biomorphic outcrops that contrasted with Taut's jagged and crystalline formations. In Mendelsohn's *Einstein Tower* (fig.48), the compact shape controls the dynamic spirals and three-dimensionality of the tower, visible from whatever angle the building is approached. The introduction of steel and concrete allowed him to exploit a freer approach towards the principles of support and loading. A radical flexibility is achieved, as the plastered surfaces appear to curve and stretch over the reinforced concrete.

In his lecture to the Arbeitsrat in 1919, entitled 'The Problem of a New Architecture', Mendelsohn characterised the possibilities of these new architectural forms in atavistic and utopian terms: 'In the unconsciousness of its chaotic upthrust, in the primitiveness of its universal embrace, the future has only one new purpose for itself to bring happiness to all peoples.' The tone of the Arbeitsrat's brand of mystical anarcho-socialism was influenced by the writer and politician Gustav Landauer. His book *Aufruf zum Sozialismus* (Call to Socialism), published in 1911, called for a radical reappraisal of values inspired by the notion of 'Geist', a German word for both mind and spirit. Just as Landauer chose the model of the medieval village community as a means of achieving this, so the Arbeitsrat called for decentralisation and the dissolution of academic institutions. The training and practice of architecture and the arts,

48
Erich Mendelsohn's Einstein Tower in Potsdam, 1919–21

freed from state control, would be based around teaching workshops and community centres.

These views were at odds with the political and economic realities of the period. Conflicts between the socialist-led republic and other left-wing factions reached crisis proportions when the Spartacist Union founded the German Communist Party at their congress on 30 December 1918. The fragile socialist coalition collapsed. In Berlin, riots and civil strife returned to the streets. Members of the Freikorps (Volunteer Corps), composed of war veterans and Horse Guard regiments, were empowered to quell the uprising. After being taken into custody on 15 January 1919, the Spartacist leaders Rosa Luxemburg and Karl Liebknecht were mercilessly beaten and shot. Notwithstanding this turmoil, a national election, conducted on 19 January

DiE LEBENDEN DEM TOTEN . ERINNERUNG AN DEN 15.JANUAR 1919

49
Käthe Kollwitz

Memorial Sheet for Karl Liebknecht 1920

Woodcut
35.5 × 49.6
(14 × 19½)
The British Museum

50
Rudi Feld

*The Danger of Bolshevism c.*1919

Colour lithograph
94 × 69.3 (37 × 27½)
The Robert Gore Rifkind Collection, Beverly Hills, California

1919, led to the formation of an assembly that was dominated by the Social Democrats. Convened in the small city of Weimar, the birthplace of the Enlightenment, it strove for a constitution based on parliamentary democracy.

Those artists whose pacifism led them to support the socialist coalition were shocked by the use of the military and state violence to crush revolutionary discontent. Of the many artistic tributes paid to Liebknecht, that undertaken by the graphic artist Käthe Kollwitz, a member of the Arbeitsrat, was the most compelling. Kollwitz had been active in the Berlin Secession before the war and, in January 1920, was the first woman to be appointed to a professorial position in the Prussian Academy. An active socialist from her youth in Königsberg, she devoted herself to depictions of the working class, concentrating on images of urban deprivation in vital drawings and prints that retained a link with naturalism.

Before the funeral of Liebknecht, several artists were invited by the family to portray the murdered leader at the morgue, where his body was laid out. Kollwitz's drawings served as the basis for the composition which, after viewing a Barlach exhibition in July 1920, she chose to explore in the woodcut medium. In the *Memorial Sheet to Karl Liebknecht* (fig.49), the subject was invested with the expressive potential and with the Christological associations of late Gothic German woodcuts. The print medium was viewed in its own right as suitable to the commemoration of a proletarian leader and the print was presented to the public at the 1920 Workers' Art Exhibition held in Berlin. It was also made available cheaply in an unlimited edition, the proceeds of which were donated to the financing of further art exhibitions for the Berlin proletariat.

When Gropius took over leadership of the Arbeitsrat, its aims became more oppositional to the new government. In March 1919, the council resolved to address the constituency of the proletariat. Naturally, their eyes turned to Russia as a model of revolutionary inspiration. Excerpts from Anatoly Lunacharsky's *Proletkult* (Proletarian Cultural Organisation) were published in *Die Aktion* on 15 March 1919. Before the Arbeitsrat was financially depleted and ceased functioning in 1921, it organised various subversive exhibitions, such as the 'Exhibition for Unknown Architects' held at the print gallery of I.B. Neumann in 1919. These exhibitions questioned the professional role of architects, dispensed with bourgeois concepts of high art and attempted to reach a proletarian audience. The equation between Expressionism and radicalism became more difficult to sustain, however, within the stabilisation of order brought about by the Weimar government.

Moreover, the revolutionary potential of the movement was undermined by the new administration's efforts to harness Expressionism as part of a broad-based democratic programme towards the arts. Members of the Novembergruppe, such as Pechstein and Klein, created anti-Spartacist posters for the government's publicity office in early 1919. These urged a return to work and to public order and encouraged citizens to vote for the national assembly. Rudi Feld's poster *The Danger of Bolshevism* (fig.50) depicts the threat of the left as a menacing cloaked skeleton with a dagger, dripping with blood, held between its teeth. Paradoxically, the link between Expressionism and state patronage, though achieving the aim of reaching a mass audience, neutralised its avant-garde status.

Indeed, the jury-free exhibitions organised by the Novembergruppe were now held under the same roof, though in separate sections, as the annual state salon. At first, their exhibits attracted a vociferous critical reception. In the June

1921 installation, however, the Novembergruppe's claim to revolutionary status came under scrutiny when they responded to the request of the Ministry of Culture to remove two works by Otto Dix and Rudolf Schlichter that were considered offensive. Members of Berlin Dada, among them Grosz, Dix, Haussmann, Hannah Höch and Schlichter, resigned in protest and announced this in an 'Open Letter to the Novembergruppe'. This appeared in *Der Gegner* (The Opponent), a journal published by Herzfelde's Malik Verlag.

The Novembergruppe was attacked for abandoning its revolutionary goals and for becoming a lackey of the state and the bourgeois buying public. Instead, Dadaists proposed as their goal, 'the surpassing of the current formulaic aesthetic stew by means of a new objectivity which will be born out of the revulsion against exploitative bourgeois society'. As it happened, the Novembergruppe's commitment to political involvement lessened but it nonetheless continued as a successful exhibiting group of modern art until its dissolution in 1933.

51
Conrad Felixmüller
The Coalminer 1920
Colour lithograph
56 × 38 (22 × 15)
Private Collection,
Herrn Titus Felixmüller,
Hamburg

Expressionist art was barely represented in state collections before 1918. Due to the democratisation of culture and to pressure exerted by the various artists' councils, it then made inroads into the public sphere. Under the guidance of the director, Ludwig Justi, the new contemporary wing of the Berlin National Gallery, which opened in August 1919, acquired a most comprehensive collection of Expressionist works. In the same year, in Hamburg, the director Gustav Pauli commissioned second generation Expressionists (members of the Hamburg Secession) to decorate the interior of a new section of the Kunsthalle. A permanent collection of Expressionist works were given prominent installation in their own hall. Such developments signalled that Expressionism, having started out as a marginalised experience of semi-private viewing, had acquired recognition as a mainstream and organic development of modernism.

In the meantime, second generation Expressionists, those born in the 1890s, had an established genealogy on which to model their avant-garde activities. Not all were coopted and validated by state approval, however. The contrasts in reception are evident in the early careers of the Dresden-born artists Conrad Felixmüller and Otto Dix. Felixmüller attended the Dresden Royal Academy between 1912 and 1915 and was self-trained as a graphic artist. In 1917, at the age of twenty, he produced powerfully disturbing coloured lithographs, based on his experiences as a military hospital orderly, and began his contribution of woodcuts to the journal *Die Aktion*. He spearheaded the formation of the Dresden Secession Group 1919 that affiliated with the Novembergruppe. The

son of a working-class family, Felixmüller committed himself to a revolutionary agenda.

When he was awarded the Saxony State Prize in 1920, instead of travelling to Rome, he embarked on a journey through the industrialised Ruhr territory in order to gather material on proletarian life. In 1923, an exhibition of these drawings and watercolours was held at the Berlin National Gallery and Justi acquired examples for the state collection. In the lithograph *The Coalminer* (fig.51), Felixmüller employed a readable, less abstract idiom, in accordance with the didacticism of his statement. The caricatured, emaciated face of the miner, blackened with coal dust, is set against a backdrop of mine shafts and coke furnaces. Man and machine are equally matched, both transformed into a startling but aesthetically modern dialect of contrasting colours and shapes.

The proliferation of graphic production in the early Weimar period was due both to ideological debates regarding the suitability of the graphic medium for reaching the broader masses and to the demand for accessible prices in an inflationary economic climate. Expressionists benefited from the exclusion of the works of living artists from the 'Luxussteuer', or luxury tax, levied in 1919 by the financially beleaguered post-war German government. Felixmüller subtly negotiated the nuances of the art market, diversifying his practice and audience. In 1920, he even encouraged the artist Otto Dix, who had recently returned to Dresden after his military service, to involve himself in graphic production. Dix apparently heeded this advice and his efforts eventually gave rise to one of the most controversial graphic portfolios of the period.

Between Autumn 1923 and the Summer of 1924, he worked on a series entitled *Der Krieg* (War), a set of fifty etchings and aquatints. Five years after the cessation of the First World War, Dix set out to publicise and to reinterpret his experiences on the front in French Flanders and Northern France. The depiction of war subject matter was not new to him. In June 1920, though based in Dresden, Dix participated in the First International Dada Fair in Berlin, which served as a forum for his anti-war works. He renounced the futurist-inspired forms of his war-time Expressionism, and mounted a devastating critique of war heroism. Based on the world that he saw around him, he uncompromisingly depicted the deformed and misshapen bodies of veteran cripples and amputees, shown begging or selling matches on the streets of the city.

In the highly competitive art market in Germany during the great inflation of the early 1920s, public or professional scandal could serve a useful purpose to artists attempting to secure their careers. The politicised nature of war themes lent itself to this procedure. Dix's painting *The Trench*, completed in 1923, was bought by the Wallraf-Richartz Museum in Cologne in October 1923. When it was exhibited at the Spring show of the Prussian Academy of Arts in Berlin in June 1924, adverse critical reception caused the return of the painting to Karl Nierendorf, Dix's dealer in Berlin. In this work, Dix portrayed the nightmarish detail of the dead, the dismembered, the decaying and the disembowelled, the putridness of trench existence also serving as a major theme in the portfolio *Der Krieg*.

Above all, many of the prints reveal Dix's nagging preoccupation with the effects of gas, the German High Command having made Ypres the testing place for the large-scale use of chlorine gas in April 1915. This was achieved amidst immense opposition by German staff and in a climate of international criticism. In closely observing the impact of poison gas, Dix used the corrosive potential of the etching medium as a metaphor for the damaging effects of chlorine on the victims. Certain works, such as *Dying Soldier* (fig.52), exploit the intaglio processes to a point where the medium assumes an energy beyond the bounds of resemblance. The adoption of these Expressionist strategies to suggest new and uncanny effects were enthusiastically described by Dix at the time:

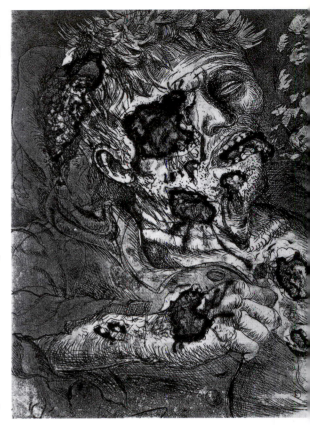

> Wash off the acid, apply the aquatint: in short a wonderful technique that lets you work on the gradations as much as you like, the process suddenly becomes enormously interesting; when you etch, you become a pure alchemist.

The portfolios met with little good fortune and, of the seventy of the total series printed, only one set of ten prints was sold to a private individual. Most of the advance publicity was returned by museum curators, Hermann Abels, of the Centre for Graphic Art in Cologne, considering the promotion a travesty that would arouse deep indignation in all former front fighters. Dix's dealer arranged for the graphics to be included both in the publication and touring exhibition 'Nie Wieder Krieg' (Never Again War) which was organised in 1924 by various pacifist groups to commemorate International Anti-War Year.

By 1925, the intense demand for graphics that characterised the immediate post-war years was over. The impact of the Dawes plan and revaluation of the mark in 1924 led to a period of relative stability; the revival of the concept of the 'artist as painter' became economically viable again. Notwithstanding the lack of market demand for the *Krieg* portfolio, when Dix moved to Berlin in 1925 his career path was firmly launched. Whereas Felixmüller retreated to the studio and became involved with more sober interpretations of the domestic milieu, Dix became associated with the movement known as Neue Sachlichkeit, or New Objectivity. In 1925, Gustav Hartlaub, now director of the Mannheim Kunsthalle, organised the exhibition 'Neue Sachlichkeit: New Painting since Expressionism', which included the works of many former Expressionists and Dadaists, among them Beckmann, Dix, Grosz and Georg Scholz. In calling for

a more concrete attitude towards representation in the preface to the catalogue, Hartlaub spoke of the need to return to traditional skills in representing the outer world in a realistic manner.

Seen as out of date, Expressionism had failed as an instrument of the revolution and its expressive and visionary concerns were regarded as a bourgeois luxury by former Dadaists, and in need of reordering by proponents of *Sachlichkeit*. Though the conflation of the 'artist as revolutionary' was laid to rest, it was precisely these political affiliations that the Nazis exhumed when branding Expressionist artists 'degenerate'.

EXPRESSIONISM'S DEMISE AND ITS LEGACY

> Expressionism today has its salon. No cigarette billboard, no nightclub manages without Expressionism. It is loathsome.
>
> Wilhelm Hausenstein, 'Die Kunst in diesem Augenblick', Der neue Merkur, 1919–20

The death knell of Expressionism, according to the art historian Wilhelm Hausenstein, lay in its commercialisation and consequent loss of authenticity. Expressionism was considered debased – it had lost its soul to mass culture. Nowadays, we tend to regard the ability of Expressionism to adapt to the demands of technological advancement as a measure of its success. The silent film *The Cabinet of Dr Caligari* (fig.53), released in Berlin in February 1920, became a resounding international success. It premiered in New York in April 1921 where it became number four at the box office; in France it spawned the movement 'Caligarisme'.

Expressionism's visibility in metropolitan life, be it in the field of museum or media culture, led its critics to interpret this as a sign of hegemony. Within the dramatic polarisation of German politics and society, views on the Left and Right targeted Expressionism. These attacks were accelerated after Hitler's rise to power in 1933. Proponents of modern art, left-wing intellectuals and Jews suffered ruthless victimisation, a violation of their human rights, burning of their books, and confiscation of their works.

The official policy of seizing so-called 'decadent' German art from public collections was authorised on 30 June 1937 by Joseph Goebbels, the minister of propaganda and enlightenment. The infamous exhibition *"Entartete Kunst"* ("Degenerate Art") was inaugurated two weeks later in Munich. Seven-hundred works, sequestered from thirty-two museums, were organised haphazardly into various categories. The installation (fig.54) focused on themes that linked modern art with moral, racial, psychological and physical degeneracy, the intention being to parody and to destabilise its claim to cultural status.

52
Otto Dix

Dying Soldier 1924, plate 26 from the portfolio *Der Krieg* (War)

Etching and aquatint on paper
19.5 × 14.4 (7¾ × 5⅝)
The British Museum

53

A still from *The Cabinet of Dr Caligari*, a film directed by Robert Wiene, 1920

Expressionism underwent transformation in exile as artists re-examined their cultural identity in light of the demands of their adoptive countries. In America, refugee artists and gallerists encountered a fairly initiated audience. During the 1930s, international modern art rapidly became institutionalised in New York. The Museum of Modern Art was founded in 1929 and an influential exhibition, *German Painting and Sculpture*, was launched in 1931. In this milieu, one of the first English language publications to publicise Expressionism was issued in 1934. Entitled *Expressionism in Art*, the book was written by the critic Sheldon Cheney, a promoter of modernism.

Cheney was neither interested in providing a historical account of the movement nor in alerting the public to its demise during the Third Reich. He distilled the language of Expressionist theory – the importance of the medium, the formal ordering of the canvas, the mystical role of abstraction, the intensity of expression – into a framework for modernism. Prised from its specific national and political context, 'expressiveness' entered the repertoire of formalist teaching and criticism.

The critic Harold Rosenberg dramatically interpreted this legacy in his article 'The American Action Painters'. He defined action painting as 'an arena in which to act'. 'Call this painting "abstract" or "Expressionist" or "Abstract Expressionist" what counts is its special motive for extinguishing the object' (*Art News*, December 1952). With the process of painting freed from depiction, its indexical status (the traces of the brushstroke) became revelatory in itself. For the vanguard artist, the act of painting offered the tension between private myth and the possibility of future self-discovery.

Interestingly, the term 'Neuexpressionisten' (Neo-Expressionists), the title of an exhibition held at Galerie Zimmer in Frankfurt in 1952, was reclaimed by German artists such as Bernhard Schultze. However, this did not constitute a direct engagement with a German cultural legacy but a form of proxy, a response to New York-based Abstract Expressionism. Neo-Expressionism, though, is regarded more as a slogan of convenience than as a term applicable to a specific movement. It refers to the re-emergence of a painterly figural tradition in the 1980s that distanced itself from the hegemony of abstraction. Its range encompassed different generations of artists and numerous artistic practices, from the *Pandemonium* manifestos of Georg Baselitz and Eugene Schönebeck of the early 1960s, to the *Heftige Malerei* (Angry Painting) exhibition held at Haus am Waldsee in Berlin in 1980, featuring the works of Rainer Fetting, Bernd Zimmer, Helmut Middendorf and Salomé.

The renewal of an Expressionist idiom has been interpreted as a search for cultural and national identity. Cold War politics and the division of Germany into an eastern and western zone, reinforced by the building of the Berlin Wall

in 1961, led to a period of historical repression of the Third Reich and the Holocaust. The debate over German responsibility for the past, which climaxed in the *Historikerstreit* (Historians' Dispute) of the 1980s, paralleled the artistic confrontation with a fragmented cultural heritage. As Expressionism came in for particular censure in the *"Entartete Kunst"* exhibition, the restoration of this legacy, as an act of defiance, reinstated artistic authenticity as central to the creative process.

The exploitation of the medium and gestural painterliness reached a climax in the cityscapes of Fetting, in which the artifice of the Berlin Wall (fig.55) or apartment blocks sweep away traces of organic life. Critically considered in the context of 'Die Neuen Wilden' (The New Fauves), the group founded an artists' cooperative, the Galerie am Moritzplatz, in the decaying area of

54

Hitler and Goebbels viewing the *Entartete Kunst* (Degenerate Art) exhibition on 19 July 1937 at the Hofgarten, Munich

55
Rainer Fetting

Van Gogh and Wall V
1978

Oil on canvas
31 × 38.5 (79 × 98)
Private Collection, Berlin

Kreuzberg. However, the increasing importance of the art market gradually supplanted avant-garde notions of communal artistic interaction. Hence, the origination of the term Neo-Expressionism cannot be separated from the context of curatorial preference, dealership and critical reception at the time. Indeed the capitalisation of the art market led various commentators to question the motivations of the artists.

Over the century, Expressionism has revealed the schism that lies between its idealistic ambitions and the reality of its commercial practices. In the context of late capitalism, these conflicts are heightened as the pursuit of an authentic statement becomes less and less feasible. However, Expressionism's ability to induce such a confrontation between painting and its critical framework attests to the strength of its abiding presence in twentieth-century culture.

SELECT BIBLIOGRAPHY

CORE READING

Barron, S. and Dube, W.D. (eds.), *German Expressionism: Art and Society*, London 1997.

Behr, S. and Fanning, D. (eds.), *Expressionism Reassessed*, Manchester 1993.

Gordon, D.E., *Expressionism: Art and Idea*, New Haven and London 1987.

Heller, R., *Art in Germany 1909–1936: From Expressionism to Resistance (The Marvin and Janet Fishman Collection)*, Munich 1990.

Lloyd, J., *German Expressionism: Primitivism and Modernity*, New Haven and London 1991.

Selz, P., *German Expressionist Painting*, Los Angeles and London 1957.

Washton Long, R-C., *German Expressionism: Documents from the End of the Wilhelmine Empire to the Rise of National Socialism*, Los Angeles and London 1995.

EXPRESSIONISM: ITS ORIGINS, MEANINGS AND HISTORIOGRAPHY

Berghahn, V.R., *Imperial Germany 1871–1914: Economy, Society, Culture and Politics*, Providence and Oxford 1994.

Blackbourn, D. and Evans. R.J. (eds.), *The German Bourgeoisie: Essays on the social history of the German middle class from the late eighteenth century to the early twentieth century*, London and New York, 1991.

Förster-Hahn, F. (ed.), 'Imagining Modern German Culture 1889-1910', *Studies in the History of Art*, vol.53, National Gallery of Art, Washington 1996.

Gordon, D.E., 'On the Origin of the Word Expressionism', *Journal of the Warburg and Courtauld Institutes*, vol.29, 1966, pp.368–85.

Jensen, R., *Marketing Modernism in Fin-de-Siècle Europe*, New Jersey 1995.

Lenman, R., *Artists and Society in Germany 1850–1914*, Manchester 1997.

Makela, M., *The Munich Secession: Art and Aesthetics in Turn-of-the-Century Munich*, New Jersey and Oxford 1990.

Manheim, R., 'Expressionismus – Zur Entstehungsgeschichte eines kunsthistorischen Stil- und Periodenbegriffes', *Zeitschrift für Kunstgeschichte*, vol.1, 1986, pp.73–91.

Milner, A., *Contemporary Cultural Theory: An Introduction*, London 1994.

Paret, P., *The Berlin Secession: Modernism and its Enemies in Imperial Germany*, Cambridge (Mass.) and London 1980.

Werenskiold, M., *The Concept of Expressionism: Origin and Metamorphoses*, Oslo 1984.

1 NATURE, CULTURE AND MODERNITY: DRESDEN

Carey, F. and Griffiths, A., *The Print in Germany 1880–1933: The Age of Expressionism*, London 1984.

Harrison, C., Frascina, F. and Perry, G., *Primitivism, Cubism and Abstraction*, New Haven and London 1993.

Heller, R., *Brücke: German Expressionist Prints from the Granvil and Marcia Specks Collection*, Mary and Leigh Block Gallery, Evanston, Illinois 1988.

Lasko, P., 'The Student Years of the *Brücke* and their Teachers', *Art History*, vol.20, no.1, March 1997, pp.61–99.

Lloyd, J., *German Expressionism: Primitivism and Modernity*, see Core Reading.

Moeller, M. (ed.), 'Fritz Bleyl', *Brücke Archiv*, Heft 18, 1993 (includes Bleyl's 'Erinnerungen', 1948, pp.206–20).

Reidemeister, L., *Künstler der Brücke an den Moritzburger Seen 1909–1911*, Brücke-Museum, Berlin 1970.

Reinhardt, G., 'Die frühe Brücke: Beiträge zur Geschichte und zum Werk der Dresdner Künstlergruppe Brücke der Jahre 1905 bis 1908', *Brücke Archiv*, Heft 9–10, 1977–8.

Reisenfeld, R., *The German Print Portfolio 1890–1930: Serials for the Private Sphere*, London 1992.

Rhodes, C., *Primitivism and Modern Art*, London 1994.

2 UTOPIANISM AND ABSTRACTION: MUNICH

Behr, S., *Women Expressionists*, Oxford 1988.

Brögmann, N. (ed.), *Marianne von Werefkin: Oeuvres peintes 1907–1936*, Lausanne and Paris 1996.

Dabrowski, M., *Kandinsky Compositions*, Museum of Modern Art, New York 1995.

Heller, R., *Gabriele Münter: The Years of Expressionism 1903–1920*, Munich 1997.

Hoberg, A., *Wassily Kandinsky and Gabriele Münter 1902–1914: Letters and Reminiscences*, Munich 1994.

Kandinsky, W., *Complete Writings on Art*, edited by K. Lindsay and P. Vergo, London 1982.

Kandinsky, W. and Marc, F. (eds.), *Der Blaue Reiter* (1912) documentary edition edited by K. Lankheit, Munich 1989.

Klee, P., *Schriften, Rezensionen und Aufsätze*, edited by C. Geelhaar, Cologne 1976.

Rosenthal, M., *Franz Marc*, Munich 1989.

Vergo, P., *Kandinsky Cossacks*, Tate Gallery, London 1986.

Weiss, P., *Kandinsky and Old Russia: The Artist as Ethnographer and Shaman*, New Haven and London 1995.

Zweite, A. and Hoberg, A., *The Blue Rider in the Lenbachhaus, Munich*, Munich 1989.

3 MODERNITY AND ITS CONFLICTS: BERLIN

Barron S. (ed.), *German Expressionist Sculpture*, Los Angeles County Museum of Art, Los Angeles 1983.

Behr, S., 'Supporters and Collectors of Expressionism', in *German Expressionism: Art and Society*, pp.45–58, see Core Reading.

Boyd Whyte, I., 'Berlin 1879–1945: an introduction framed by architecture', in Rogoff, I. (ed.), *The Divided Heritage: Themes and Problems in German Modernism*, Cambridge 1991, pp.223–52.

Calvocoressi, R. (ed.), *Oskar Kokoschka 1886–1980*, Tate Gallery, London 1986.

Eliel, C., *The Apocalyptic Landscapes of Ludwig Meidner*, Los Angeles County Museum of Art, Los Angeles 1989.

Friedrich, T., 'A Turn toward the Public? The Expressionists' Media: Books, Posters, Periodicals', in *German Expressionism: Art and Society*, pp.85–9, see Core Reading.

Grosz, G., *An Autobiography* (1946), translated by Nora Hodges, foreword by B. McCloskey, Los Angeles and London 1998.

Haxthausen, C. and Sühr, H., *Berlin, Culture and Metropolis*, Minneapolis and London 1990.

Levine, F.S., *The Apocalyptic Vision: The Art of Franz Marc as German Expressionism*, New York 1979.

Morris, K. and Woods, A., *Art in Berlin 1815–1989*, Seattle and London, 1990.

Schwartz, F., *The Werkbund: Design Theory and Mass Culture before the First World War*, New Haven and London 1996.

Werckmeister, O.K., *The Making of Paul Klee's Career 1914–1920*, Chicago 1984.

Winskell, K., 'The Art of Propaganda: Herwarth Walden and *Der Sturm* 1914–1920', *Art History*, vol.18, no.3, September 1995, pp.315–44.

4 WAR, REVOLUTION AND COUNTER-REVOLUTION

Barron, S. (ed.), *German Expressionism 1915–1925: The Second Generation*, Munich 1989.

Behr, S., *Conrad Felixmüller 1897–1977: Works on Paper*, Courtauld Institute Galleries, London 1994.

Benson, T. (ed.), *Expressionist Utopias*, Los Angeles County Museum of Art, Los Angeles 1993.

Eberle, M., *World War I and the Weimar Artists: Dix, Grosz, Beckmann, Schlemmer*, London and New Haven 1985.

Guttsman, W.L., *Art for the Workers: Ideology and the Visual Arts in Weimar Germany*, Manchester 1997.

Heller, R., *Stark Impressions: Graphic Production in Germany 1918–1933*, Mary and Leigh Block Gallery, Evanston, Illinois 1994.

Herzogenrath, W. and Schmidt, J.K. (eds.), *Otto Dix: zum 100. Geburtstag 1891–1991*, catalogue, Galerie der Stadt, Stuttgart, 1991.

Kaes, A., Jay, M. and Dimendberg, E. (eds.), *The Weimar Republic Sourcebook*, Los Angeles and London 1994.

Irwin Lewis, B., *George Grosz: Art and Politics in the Weimar Republic*, New Jersey 1991.

Weinstein, J., *The End of Expressionism: Art and the November Revolution in Germany, 1918–1919*, Chicago and London 1990.

Weinstein, J., 'Expressionism in War and Revolution', *German Expressionism: Art and Society*, pp.35–44, see Core Reading.

LEGACIES

Barron, S., *Degenerate Art: The Fate of the Avant-garde in Nazi Germany*, Los Angeles County Museum of Art, Los Angeles 1991.

Barron, S. and Eckmann, S., *Exiles and Emigrés: The flight of European Artists from Hitler*, Los Angeles County Museum of Art, Los Angeles 1997.

Buchloh, B.H.D., 'Figures of Authority, Ciphers of Regression: Notes on the Return of Representation in European painting', *October*, vol.16, pp.39–68, 1981.

Cheney, S., *Expressionism in Art* (1934), New York 1962.

Foster, H., 'The Expressive Fallacy', in *Recodings: Art, Spectacle, Cultural Politics*, Port Townsend 1985, pp. 59–77.

Krens, T., Govan, M. and Thompson, J. (eds.), *Refigured Painting: The German Image 1960–1988*, Munich 1989.

Kuspit, D., *The New Subjectivism: Art in the 1980s*, New York 1993 (includes pivotal articles from *Art in America* and *Artforum*).

McShine, K., *Berlin Art 1961–1987*, Munich 1987.

PHOTOGRAPHIC CREDITS

COPYRIGHT CREDITS

INDEX